Protest in Paris 1968: Photographs by Serge Hambourg

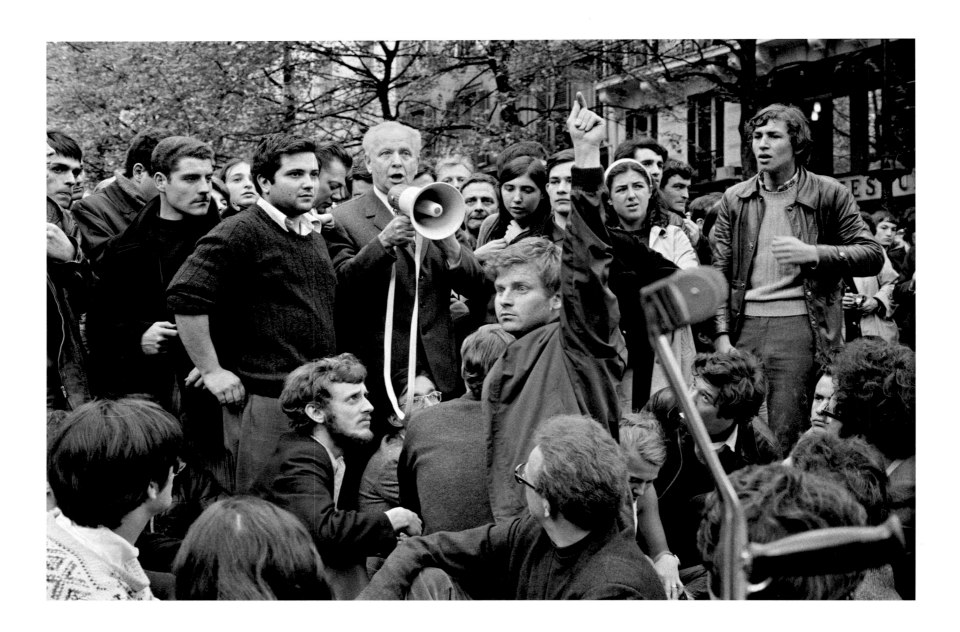

Protest in Paris 1968: Photographs by Serge Hambourg

Essays by Anne Sa'adah and Thomas Crow

Introduction by Katherine Hart

Hood Museum of Art, Dartmouth College

HANOVER · NEW HAMPSHIRE · 2006

Distributed by University Press of New England

HANOVER AND LONDON

© 2006 by the Trustees of Dartmouth College
ALL RIGHTS RESERVED
Hood Museum of Art, Dartmouth College,
Hanover, New Hampshire 03755
www.hoodmuseum.dartmouth.edu

Distributed by University Press of New England
One Court Street
Lebanon, New Hampshire 03766
www.upne.com

Protest in Paris 1968: Photographs by Serge Hambourg
Hood Museum of Art, Dartmouth College
Hanover, New Hampshire
September 9–November 18, 2006

This exhibition was generously funded by the
Parnassus Foundation, courtesy of Jane and Raphael Bernstein.

Edited by Nils Nadeau
Designed by Dean Bornstein
Printed by Capital Offset Co., Inc., Concord, New Hampshire

ISBN 0-944722-32-6

COVER: Cat. 6. Crowd of marching protestors with sign reading
"Sorbonne Teachers against Repression," May 10, 1968. (detail)

BACK COVER: Cat 15. View down the boulevard toward the Panthéon,
May 11, 1968.

FRONTISPIECE: Cat. 2. Writer Louis Aragon addressing the crowd through
a bullhorn at the Place de la Sorbonne; student leader Daniel Cohn-Bendit
with arm raised, May 9, 1968.

LIBRARY OF CONGRESS CATALOGING-IN-PUBLICATION DATA

Hambourg, Serge.
 Protest in Paris 1968 / photographs by Serge Hambourg ; essays by Thomas
Crow and Anne Sa'adah.
 p. cm.
 Catalog of an exhibition Sept. 9–Nov. 18, 2006.
 Includes bibliographical references.
 ISBN 0-944722-32-6 (pbk.)
1. Hambourg, Serge—Exhibitions. 2. Documentary photography—Exhibi-
tions. 3. General strike, France, 1968—Pictorial works—Exhibitions. 4. Riots—
France—Paris—Pictorial works—Exhibitions. 5. College students—France—
History—20th century—Pictorial works—Exhibitions. I. Crow, Thomas E.,
1948– II. Sa'adah, Anne. III. Hood Museum of Art. IV. Title.
 TR647.H3465H36 2006
 779'.99443610836—dc22
 2006026593

Contents

Foreword and Acknowledgments

The turbulent events in Paris in 1968 were part of a decade that saw many protests—in support of the American civil rights movement and feminism, and against American involvement in the Vietnam war, to name a few. Documentary photography published in newspapers and magazines and shown on television played an especially important role in stimulating the ferment. Searing images from the Vietnam war era, such as the Kent State student kneeling next to a fallen protestor, or the picture of a screaming Vietnamese girl fleeing napalm as she runs toward the camera, powerfully affected attitudes toward that conflict and the student protests against it.

In contrast to these well-known images, most of Serge Hambourg's photographs of Paris in May of 1968 are being published here for the first time. During this turbulent year he was working as a photojournalist for the weekly left-leaning magazine *Le Nouvel Observateur*. He first photographed the student protest leader Daniel Cohn-Bendit talking to a group at Nanterre University in early March and then followed the numerous demonstrations and meetings as events heated up later that spring and summer. Some of these images were printed at the time in *Le Nouvel Observateur*. Most of them, however, have been filed away until now. We would like to thank Serge Hambourg for his great generosity in making them available to the Hood Museum of Art for this exhibition. Of course, this is not the first time that Dartmouth has showcased the work of this fine photographer. In 1988 the Hood exhibited color photographs of New England mills and factories that Serge Hambourg produced between 1982 and 1985. It is a pleasure to collaborate with him once again on presenting this earlier body of work.

College and university museums often collaborate with faculty in investigations of visual culture and its relation to society, politics, and other art forms. For this project, we were most fortunate to be able to work with the distinguished scholar Anne Sa'adah, Joel Parker Professor of Law and Political Science, Department of Government, Dartmouth College, who lent her expertise on French politics, society, and culture to the interpretation of these images. For this catalogue she contributed a scholarly essay illuminating the political conditions surrounding the protests and the various personalities recorded by Serge Hambourg on film. In addition, Thomas Crow, Director of the Getty Research Institute, has written an engaging essay on the artistic aspects of the protests, and we thank him for his encouragement and involvement in the catalogue.

This exhibition would not have reached fruition without the support and deep interest of the Parnassus Foundation and Raphael and Jane Bernstein, decades-long supporters of Serge Hambourg's work. We are indebted in particular to Raphael Bernstein's insightful comments and advice, as well as his dedication to the interdisciplinary aspects of this presentation of Hambourg's work. Additional thanks are due to Jeannie Baxter and Ed Burtynsky of Toronto Image Works and their staff for overseeing the printing of the photographs for the exhibition and catalogue. Dean Bornstein is to be commended for his sensitive design of the catalogue.

The exhibition's genesis was overseen by former director Derrick Cartwright, who brought Anne Sa'adah into the process and first engaged in substantive discussions with Raphael Bernstein about the exhibition's scope and concept. Katherine Hart, Associate Director and Barbara C. and Harvey P. Hood 1918 Curator of Academic Programming at the Hood Museum of Art, has overseen all aspects of this project. Her professionalism, sensitivity, and commitment to interdisciplinarity are of vital importance to this institution, and I thank her for her support and unfailing dedication. The following members of the Hood Museum of Art staff are to be applauded for their work in the implementation stage: Nils Nadeau, Juliette Bianco, Nancy McLain, Roberta Shin, Sharon Reed, Mary Ann Hankel, Lesley Wellman, Kristin Monahan,

Patrick Dunfey, Kellen Haak, John Reynolds, and Matt Zayatz. Curatorial interns Sandra Van Ginhoven and Abigail Weir assisted Katherine Hart with numerous details as the catalogue went to press.

It is our hope that this exhibition and catalogue will illuminate the events of 1968 for today's college and university students, demonstrating how they have shaped our own political consciousness at the beginning of the twenty-first century. Greater comprehension of the key events that defined the postwar generation, along with a developed sense of history, will make for more considered and informed choices within the democratic system that prospers through our participation today.

—Brian Kennedy
Director

Introduction

The spectacle is not a collection of images, but a social relation among people that is mediated by images.

—Guy Debord
The Society of the Spectacle[1]

Of what value are photographs when reflecting upon historic events? Many are compelling images that give the look and feel of a time that is past—the way people dressed, their fleeting expressions, the particularity of a place at a certain day and hour. What truths are to be gleaned from them, if any? Why do some photographs become symbolic of an entire era? The most famous are studied more for their impact than their status as historical documents—the standing hooded figure from Abu Ghraib, the kneeling figure of a Kent State student, the execution of a captured Viet Cong fighter, the Rwandan youth with machete scars fanning across his face. Are photographic images a stumbling block or an aid to understanding the events that they capture? With these questions in mind, this catalogue presents thirty-five images of the famous events of May 1968 in Paris by the photographer Serge Hambourg. In the company of a scholarly essay by a political scientist and a critical essay by an art historian, the photographs speak within the parameters of a measured and analytical account of their times. This marriage of images and interpretation gives us perhaps a more tangible sense of the climate of dissent, of what it might have been like building barricades or defending the status quo in the capital of France in 1968.

Black-and-white photographic images produced from film negatives—paper printed with light and dark tonalities that define surface, volume, and texture—are visual records. Before digital capture and tampering with images became commonplace, photographs were often given more weight than a written description by a witness. The camera was considered a relatively impartial observer that neither lied nor was influenced by emotion. We are more suspicious of images now—that they might be posed, staged, or digitally altered, or that they exist because the photographer chose to photograph some events and people and not others. (Their exhibition, of course, reflects further choices by a curator, who is editing images for reasons of subject and aesthetic interest.) We are also conscious that photographs are taken from a particular perspective and only partly describe the scene or context. The field of vision is usually confined to a rectangular shape, the edges of the frame often showing a partial view of an object or figure. A figure moving into or out of the image (cropped either by the parameters of the camera lens or in the darkroom) provides the sense of immediacy and action—the intimation that the photographer is part of what she or he is capturing on film—that we have come to expect in documentary photography.

A blurred image, graininess, or out-of-focus areas are also typical of photographs taken quickly in difficult circumstances, when a subject is moving faster than the film and shutter speed of the camera. A foundation stone of photographic journalism is the famous image from 1936 by Robert Capa of a soldier at the moment that he is shot in the head during the Spanish Civil War.[2] His body falls backward, his limbs, face, and rifle slightly out of focus.[3] In one of the photographs by Serge Hambourg in this catalogue, the blurred figure of a running policeman holding a rifle while others enter from the left, one only partially in the frame (cat. 10), can easily be read as a moment of frenetic and tense activity. Although some doubt has been cast on Capa's image, both have the hallmarks of the unposed photograph, which adds to their ability to convince us that they are showing real events.

A skewed background is another visual commonplace in documentary photography. Ed Grazda, a freelance photojournalist who has worked in Afghanistan for over twenty-five years, took a picture of two of his Taliban minders at Jadi Maiwand, Kabul, in February 1997 (fig. 1), just prior to the Taliban's photography ban.

Still, there were restrictions on what he was able to photograph. One of the men turns toward him, half of his face revealing an intense gaze, furrowed brow, and pursed lips. The tilted landscape of the city behind the two figures gives the sense of a particular moment captured in time, perhaps on the sly. The lopsided angle also contributes to the destabilizing feeling of being caught, as the camera records a confrontation between the subject and the photographer. Serge Hambourg's askew photograph of policemen nonchalantly dragging an uncooperative protester by his sweater (cat. 35) captures a telling encounter between two different sides during a demonstration in June by writers and artists. The quick release of the camera lens, at the cost of a carefully framed subject, acts to convince us that we are seeing a fleeting glimpse of an actual event. The camera itself also has its own vision, one that can freeze a moment we might not see at all with our own eyes, complicating the nature of what we are actually looking at in a photographic image. Some of the most powerful images are those that simulate the feeling of actually being there with the photographer.

Regardless of their power to convince, providing contexts for photographic images is important if they are to be read as documents of the past. Knowing about the Taliban's aversion to Western technology or any outside influence, its eventual ban on photography, and its support of groups hostile to Western systems and values reinforces the impression of wariness in the figures in Grazda's image. Another image that benefits from such context is a 1939 Capa photograph showing a woman running across an open square (fig. 2). The information contained in the title *Running for Shelter During Air Raid, Barcelona, January, 1939* lends an eeriness to the image that it does not intrinsically possess. There are no signs of airplanes or destruction. Capa has caught most of the woman (except her legs and feet) in focus, but there is little depth of field and the background is blurred. Without the title, the style of the woman's dress still hints at when the photograph was taken, but its context and the motivation for her flight only reveal themselves relative to an actual event.

Serge Hambourg's photographs of Paris in May and June of 1968

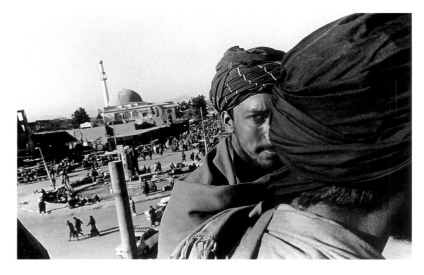

fig. 1. Ed Grazda, American, born 1947, *Taliban at Jadi Maiwand, Kabul, Afganistan,* February 1997, gelatin silver print. Purchased through the Harry Shafer Fisher 1966 Memorial Fund; PH. 2004.68.

were taken during a time of upheaval and social spectacle. Anne Sa'adah's essay in this catalogue describes the intense frustration on the part of students that escalated quickly into demonstrations and clashes between police and protestors. The inept reaction of the government in turn led to workers' strikes, and general upheaval precipitated the dissolution of the French National Assembly and new general elections. Sa'adah's essay describes the complexity of the situation and the varying factions among the left that vied to become the arbiters of the message of reform, as well as the initial misunderstanding by political leaders of the serious nature of the uprising.

What do Hambourg's photographs themselves tell us about these events? Certainly those of us accustomed to images of counter-culture American protestors will note the more conservative dress of their French counterparts, as Sa'adah points out: the men are in corduroy jackets (cat. 20), sweaters, or button-down shirts and ties (cat. 9); some of the women are in skirts (cat. 21). Hambourg's work also reveals that most of the protestors were men. One image (cat. 6) shows students and teachers (mostly in the background) marching forward en masse toward the camera. The sea of heads is

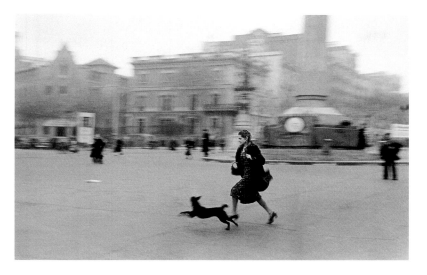

fig. 2. Roberta Capa, American, 1913–1954, *Running for Shelter During Air Raid, Barcelona, January 1939* (printed 1996), gelatin silver print. Purchased through an Anonymous gift; PH.2003.9.

in perfect focus, so you can see the expressions of many of the faces (Hambourg must have been slightly elevated or was holding his camera above him).[4] The banner toward the left in the middle distance proclaims that some of the protestors were lecturers from the Sorbonne (University of Paris) marching "against repression." One senses the seriousness and determination of the protestors as well as the impressive numbers that had joined the demonstration.

Hambourg is attuned to the mood of the various moments he captures during his monitoring of the protests and barricade building. The orderliness of the May 10 march is in keeping with images of police unperturbedly holding back the crowds (cat. 3) and the overall calm before the storm that would occur that night. (There had been violent clashes earlier in the month, but the most serious of them occurred after 2 a.m. during the early morning of May 11.)[5] These May 10 photographs are in contrast to the figures jostling one another at the Place de la Republique at the joint worker and student march three days later (cat. 22) and the tense expression of the student leader Jacques Sauvageot that same day (cat. 17). Another image from this later demonstration, however, shows protest leaders Daniel Cohn-Bendit and Alain Geismar relaxed and smil-

ing as they march with Sauvageot (cat. 16). These shifts of mood underscore the fact that photographs collect only transitory moments, and they cannot be representative of an entire event. What these images do capture is that Sauvageot was reacting differently to his role than his two colleagues. Similarly, the nature of the exchange between Daniel Cohn-Bendit and the writer Louis Aragon on May 9 (cat. 2) cannot necessarily be read from the photograph for what it was reported to be—a confrontation between two speakers (see Sa'adah's essay, p. 38).[6] It appears instead as if they might be on the same side.

During these crucial days of May 9 through 13, Hambourg also trained his camera on more isolated events that he witnessed, such as a lone protestor surrounded by policemen with guns (cat. 9) or the group of policemen standing on the sidewalk and looking down the avenue (presumably toward marchers), while one of them takes the opportunity to snap a picture with his own camera (cat. 8). Shots such as this latter one indicate that there were moments of respite from the action. Anne Sa'adah tells us that the chief of police was determined that there would be no casualties, and this photograph (and others not published here) shows a more relaxed attitude on the part of law enforcement. They also illustrate how much of the police's time was spent waiting for orders as they monitored the situation. The building of the barricades attests to the frenetic activity of the students and sympathetic Parisians (cat. 11, 12), while the image of the older woman and man in a hat, who stand in front of a sidewalk café calmly surveying the debris of the uprooted cobblestones and street signs (cat. 13), shows that these events provided a spectacle for ordinary Parisians. As a photographer, Hambourg has an eye for the individuals he photographs, and he often sees the telling image of everyday life and activity in the midst of what might otherwise be considered the main event.

The preferences and aesthetic sense of the photographer, the nature of the events, and the expressions and personalities of the individuals who participate or observe—all of these factors lead to images that describe fragments of the past. For the curious and uninitiated, these photographs of Paris will lead to questions about

what was going on and who the people pictured are. To those who study or lived through these events, they are a source of information and a spark to memory, what Serge Hambourg has described as a "slice of life" during what was one of the most interesting spectacles of that era. The events in Paris that year were a spontaneous and exuberant expression of political dissatisfaction and the hope for change, an uprising that cut across boundaries of class and profession. They embodied the energy and engagement of that decade's youth, a phenomenon that reached across cultures and nations. Hambourg captures the force of that cultural moment, and his photographs become part of its memory, joining with written accounts by witnesses, political analysis, social commentary, filmed footage, films, posters, performance, art, novels, and other photographs in a patchwork quilt of social science and artistic representation. Taken together they provide a compelling picture of the legacy of 1968.

—Katherine Hart
Associate Director
Barbara C. and Harvey P. Hood 1918
Curator of Academic Programming

NOTES

1. "Le spectacle n'est pas un ensemble d'images, mais un rapport social entre des personnes, médiatisé par des images." Guy Debord, *La Société du Spectacle* (Paris: Éditions Gallimard, 1992 [published originally in 1967]), p. 4.

2. Due to the subsequent testimony of a fellow reporter, Robert Capa's *Fallen Soldier,* taken in September 1936 during the Spanish Civil War, is suspected of being staged. Regardless, this image had a powerful impact on photojournalism and also was instrumental in raising funds for the Republican cause after it was reproduced in magazines in Europe and the United States.

3. Brian Wallis, chief curator of the International Center of Photography, spoke of the great changes in photography since Capa's time for his Dr. Allen W. Root Contemporary Art Distinguished Lectureship "Keeping It Real: Photography, Art, and Globalism" at the Hood Museum of Art on November 11, 2005.

4. A note on Hambourg's role as a photojournalist at the time: he was employed by the magazine *Le Nouvel Observateur* and was using Nikon F and Leica M2 cameras. The images in this catalogue were made from digital scans of his negatives.

5. Hambourg did not photograph the violent confrontations that night but did take a series of shots from a distance of the bonfires on the streets near the Sorbonne, as well as some students building barricades (cat. 11).

6. Hambourg, who obviously witnessed the exchange, describes the scene as the flinging back and forth of insults. In addition to the one published in this catalogue (cat. 2), he took a series of photographs of this confrontation.

Challenging Authority: The Student Protests of May 1968 and the Transformation of French Society

ANNE SA'ADAH

In the late spring of 1968 French students went on strike. French workers followed, and by the middle of May, seven to ten million people were on strike—in a country whose total population stood at about fifty million. Normal activity ceased. The President of the Republic briefly vanished. No one knew what would happen next. In the short run, elections happened—and conservative forces won overwhelmingly. But their victory was pyrrhic in many respects. The strikers of 1968 were protesting a style of authority previously manifest in family life, the school system, the workplace, and politics. In the aftermath of the strikes, that style of authority never recovered. Major French institutions—including the educational system and the political system—moved into a period of adjustment whose uncertainties were soon compounded by the economic crisis that began in 1973. Feminism, gay rights, antiracism, and an impatience with centralized institutions of all sorts spawned new forms of organization and collective action, while older institutional powerhouses like the communist party declined. The centralized Jacobin state, which had been the mainstay of France's ability to project power internationally, also never recovered, producing an often anguished debate about French identity, citizenship, and the value of sovereignty. May 1968 was thus in many respects both an end and a beginning.

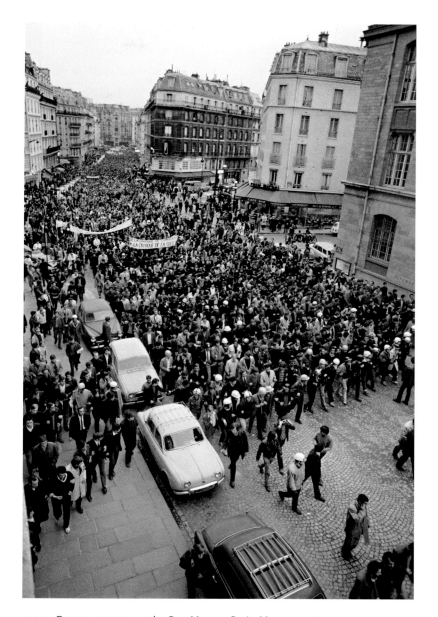

cat. 7. Demonstrators on the Rue Monge, Paris, May 10, 1968.

The French "events" of May 1968 constitute a significant episode in a number of different stories, each with a distinctive chronology. Four of these stories—one international, three French—are particularly worth mentioning, and contemporary actors were aware of them all. First, the events can be seen as part of a wave of

unrest, often spearheaded by students, that affected a wide range of countries in the 1960s: the United States, the People's Republic of China, Mexico, Czechoslovakia, and the Federal Republic of Germany. Second, the events can be seen as part of a French tradition of mass protest, starting with the great *journées* of the revolutionary period (of which the most famous was the *journée* of August 10, 1792, credited with toppling the monarchy and destroying the vestiges of feudalism) and extending through the insurrectionary riots of July 1830, the June Days of 1848, the Commune of 1871, the rightwing riots of February 4, 1934, the sitdown strikes of 1936, and finally the "antiglobalization" strikes of December 1995. Third, the events can be analyzed as an episode in the postwar social, economic, cultural, and political transformation of France: other key references in this story would include the economic prosperity of the 1950s and 1960s, the advent of the Fifth Republic under the leadership of Charles de Gaulle in 1958, the termination of the Algerian War and the effective end of the French Empire in 1962, the resignation of Charles de Gaulle in April 1969, the liberalizing social reforms of the 1970s, the victory of the left in the elections of 1981, the first experiment with "cohabitation" (divided government) in 1986, and the debates surrounding European integration in and beyond the 1990s. Finally, the events can be portrayed as a relatively self-contained story, triggered by ongoing campus tensions at Nanterre (a then-new but already overcrowded university in the suburbs of Paris) in March 1968 and ending with the conservative victory at the polls in June 1968.

This last story—while in itself the least satisfying in interpretive terms—is a necessary element in any of the other possible analyses. Here then is a chronological summary of what transpired in France between March and June 1968. Like all good French stories, it is divided into three parts: authority challenged, authority in retreat, and authority restored.

Authority Challenged

March 15 *Le Monde,* France's newspaper of record, publishes a column entitled "Quand la France s'ennuie" ("When France is bored"): "The characteristic trait of our public life," Pierre Viansson-Ponté wrote, "is boredom. The French are bored. They are neither direct nor indirect participants in the great convulsions that are shaking the world. . . . In a little France more or less reduced to the Hexagon, neither really unhappy nor really prosperous, at peace with the world, without leverage on world events, ardor and imagination are as necessary as well-being and economic growth. . . . At the limit, a country can die of boredom—it has been known to happen."

March 22 Student protesters occupy administrative offices at Nanterre.

May 2 Nanterre shut by order of its dean, Pierre Grappin. Prime Minister Georges Pompidou leaves for a state visit in Afghanistan.

May 3 Police, called by the university rector, clear the courtyard of the Sorbonne of protesting students. The police action provokes massive street demonstrations, resulting in hundreds of arrests and dozens of injuries. Classes are suspended.

May 4–5 Four students are sentenced to two months in prison.

May 6 Renewed demonstrations in the Latin Quarter; unrest in the provinces.

May 8 More demonstrations in Paris and the provinces.

May 9 Students heckle the communist poet Louis Aragon (cat. 2). Education minister Alain Peyrefitte orders the resumption of classes; students threaten to occupy the Sorbonne; the university remains shut. Disciplinary proceedings against Daniel Cohn-Bendit and other Nanterre students are suspended.

May 10–11 Night of intense street confrontations in Paris, where demonstrating students build barricades (see fig. 8 on p. 27, cat. 11 and 12).

May 11 Prime Minister Pompidou returns to Paris.

May 13 Country-wide general strike, initially for twenty-four hours; for the next two weeks, the French economy essentially shuts down, as wildcat and sitdown strikes spread (cat. 16–23). Joint demonstrations (students and trade unionists) in Paris. Students occupy the Sorbonne.

May 14 General De Gaulle, President of the Republic, leaves for a state visit to Romania.

May 15 The Odéon Theater (on the Left Bank) is occupied.

May 17 The national radio and television authority (ORTF) goes on strike.

Authority in Retreat

May 19 De Gaulle returns to Paris; in an uncharacteristic moment of public vulgarity, he famously—and imprudently—describes the situation as a *chienlit* (mess). The students turn the expression against him, putting up posters saying "La chienlit, c'est lui" (fig. 10, p. 29).

May 21–22 In the National Assembly, a motion of censure against the government is debated but fails by eleven votes.

May 22 The government revokes Daniel Cohn-Bendit's residence permit; more demonstrations take place.

May 24 De Gaulle delivers a national address on both radio and television; speech fails to demobilize strikers.

May 24–25 Another night of street battles in Paris; the stock exchange is set on fire. In Paris, a student dies under circumstances never fully elucidated; in Lyon, a police officer is crushed to death by a driverless truck launched in his direction by demonstrators.

May 27 Representatives of the government, the trade unions, and management sign the Grenelle Accords, but the terms of the agreement are rejected by striking workers and the strikes continue. Political rally by the left at the Charléty stadium.

May 28 Political figures on the left propose the formation of a new government.

May 29 De Gaulle briefly vanishes.

Authority Restored

May 30 De Gaulle returns to Paris and addresses the nation by radio, affirming his intention to remain in power. New parliamentary elections are called for June. Huge pro-regime demonstration occurs on the Champs-Elysées (cat. 29–33).

June 1 Protestors return to work in the public sector (excluding the school system).

June 7 Televised interview with de Gaulle by Michel Droit. Extremist opponents of decolonization convicted for subversion and/or violent acts during the early 1960s are amnestied by the government.

June 10 A high school student drowns while fleeing police during a demonstration at the Renault factory in Flins.

June 11 Two workers are killed, one by a police bullet. Demonstrations in Paris; more barricades, hundreds of injuries and arrests.

June 12 The government bans further demonstrations and dissolves several leftist *groupuscules*.

June 14 Police clear the Odéon Theater.

June 16 Police clear the Sorbonne.

June 17 Most people back at work.

June 23, 30 Legislative elections result in a conservative victory.

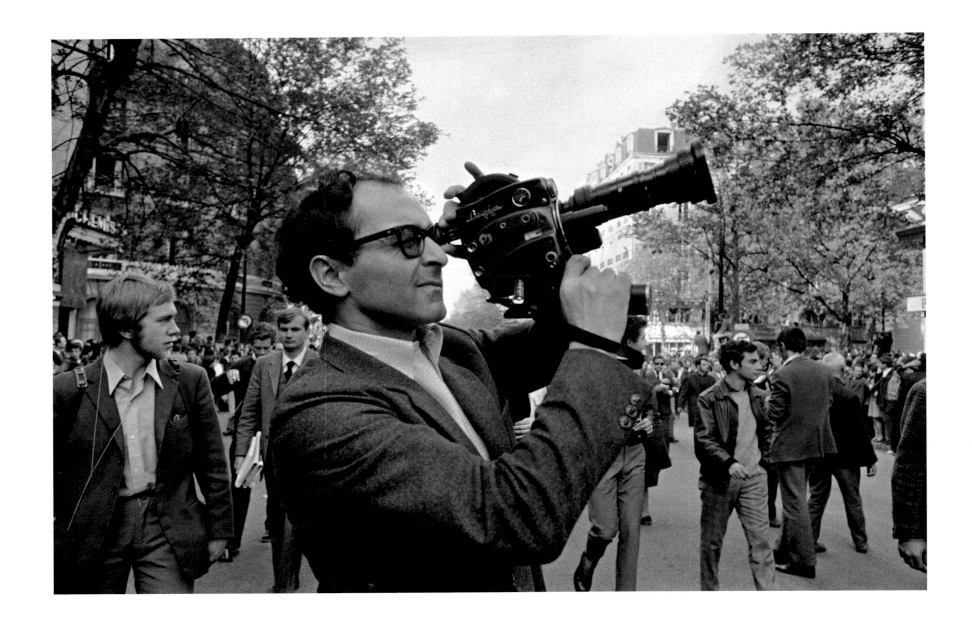

cat. 18. Jean-Luc Godard filming, May 13, 1968.

The Beach beneath the Paving Stones: May 1968 and the Visual Arts

THOMAS CROW

The photographs of Serge Hambourg document a time and place that does not seem so remote from our own. Yes, the events are extraordinary, but student demonstrations remain a regular fixture of Parisian life: an enormous outpouring of protest has within just the last few months forced the government to back down over employment reforms. In the photographs, the fashions appear only a little out of date; the landmarks of the Left Bank appear as one still knows them.

At the same time, nonetheless, we have crossed a divide in history that has left us peering across an invisible barrier and requiring an intellectual map in order to decipher Hambourg's images. One print (cat. 18; see also fig. 3) captures the famous filmmaker Jean-Luc Godard sighting his portable camera at something above eye level. A certain *cinéma-vérité* realism is implied by the style of the photograph itself. But that supposition changes with the information that Godard filmed the demonstrations and their graffiti with a view to creating what were called *ciné-tracts*—three-minute inter-cuttings of static shots with revolutionary slogans: "Take a photo and statement by Lenin or Che," he advised, "divide the sentence into ten parts, one word per image, then add the photo that corresponds to the meaning either with or against it."[1]

So the meaning of Hambourg's photograph alters with the knowledge of the specific positions and arguments taken by the two artists. Godard contested the capacity of any form of straight photography to articulate the historical reality underlying a given scene. It was imperative for him that the apparently unified and immediately sensible impression of the photograph be recognized as an illusion—interrupted, broken down, and mixed with blunt textual prompts as a spur to analytical thinking.

In aid of what, though? One needs to ask the question, in that the aims of mass dissent have drastically narrowed in the intervening decades. The recent round of French student and labor protests, though counted in the millions of participants and replete with violent confrontations and police arrests, had as its purpose the repeal of some relatively modest neo-liberal legislation concerning employment rights, albeit egregiously targeted only at young people. The protesters of May 1968 included many who were convinced that the moment had arrived for no less than a socialist transformation of French politics and society. With that hope came an intensified fear of failure, of the prospect that the uprising would go the way of so many others extending back to the great Revolution of 1789, falling short of its goals and leaving a restored establishment barely altered by the ordeal. Hence Godard's urgency.

Hence also the intensified debate in 1968 over tactics between advocates of a controlled, organized effort and those protestors who regarded improvised spontaneity as the only antidote to the compromises endemic to political organizations. Both sides, however, took as fundamental the need to exploit the modern media for their own purposes. Godard and his collaborators belonged to the first group and sought to bend cinema into a tool capable of fostering a cool, unsentimental appraisal of underlying forces and contradictions. Among Godard's opponents were the Situationists, under the firm direction of Guy Debord, likewise a (sometime) filmmaker but one who despised what he saw as Godard's mere representation of freedom, as opposed to a genuinely free, uncoerced communication beyond art: "If one really insists on finding something positive in modern culture," wrote Debord, "it must be said that its only positive aspect lies in its self-liquidation, its withering away, its witness against itself."[2]

17

fig. 3. Jean Luc Godard filming demonstrators, May 13, 1968.

For all of the finality of that verdict, every grouping and alliance among the students and intellectuals who sparked the May 1968 uprising manifested a preoccupation with issues of art. A seemingly parochial dispute inside the closely knit Parisian film world in fact proved to be the incubator and test run for the May events. In February, the long-serving director of the Cinémathèque Française, Henri Langlois, had been abruptly dismissed by the state minister of culture, even though the institution was ostensibly an independent cooperative. Langlois was revered for his creation of one of the world's leading film archives, and for his programming, which had introduced the new generation of French directors and critics to the great Hollywood studio legacy while providing a venue for the newest and most experimental of French productions.

It was the last that a watchful government may eventually have found intolerable, though the usual bureaucratic excuses were supplied. Its action almost immediately sparked a series of large demonstrations, an international movement of solidarity, and an ongoing campaign that stretched into April, by which time the entire tenor of the protest had shifted from a matter of individual rights to a broad effort to ally cinema with working-class activism. For all of that, however, the characteristic preoccupations of an educated minority in possession of specialized technical and aesthetic expertise remained front and center in the much larger events to follow. Hambourg captures one sign of that phenomenon in the flamboyant found graffito on the wall alongside a relatively tranquil portrait (cat. 25) of two students on strike in front of the Institut Louis

Pasteur: "Liberez L'Expression," reads the slogan that frames the photogenic couple, who might themselves have stepped directly out of a *nouvelle-vague* film.

This conjunction brings to the surface a strain of ambivalence in the radical French movements and art forms of the 1960s toward the products of American-style capitalism, which in every other respect, especially as manifested in the aggressive militarism of the Vietnam war machine, were the target of protest by the left. The famous cinematic "new wave" of the early 1960s—embodied in films by Godard, François Truffaut, and Claude Chabrol, among others—emerged from Langlois's school of Hollywood, which these intellectuals transformed into a fresh idiom full of knowing but distanced references to their American models. In Godard's *Contempt* (*Le Mépris*) of 1963, a screenwriting character played by Michel Piccoli (who stands in for Godard himself) insists on wearing a porkpie hat and smoking a cigar in the bath. When his wife, played by Brigitte Bardot, sneers at the affectation, he explains that he is modeling himself on Dean Martin in Vincente Minelli's 1958 film *Some Came Running*.

Godard's design of the film also represents a French point of entry for the American sensibility of Pop Art in painting. In a long central scene, for example, Bardot switches back and forth from her own loose blonde hair to a tight black wig, tracking the duality that Andy Warhol had established the year before in his silkscreen portraits of Marilyn Monroe and Elizabeth Taylor. Is this homage or simultaneous invention? Given the close interval in

time between the two phenomena, it is difficult to tell, but by 1965 American Pop had become a chic Parisian passion. Warhol arrived in Paris in May with Edie Sedgwick, the heiress, model, and underground society sensation. Their presence and an exhibition of his flower paintings, with their bright slabs of uniform color, sparked a delirious critical and public response.[3]

Some of that receptivity no doubt came from the longstanding seriousness with which the French have treated *la bande dessinée*, the comic strip. The most characteristic Situationist vehicle of the period was not in fact film but that more modest and ubiquitous medium—"the only truly popular literature of our century," in the words of one polemicist—altered and embellished to carry messages contrary to its original purpose of mind-numbing entertainment.[4] Lying behind this enterprise, though as a thoroughly negative case, was American-style Pop, derided by the Situationists for breaking comics up into fragments that appealed to a chic taste—the paintings of Roy Lichtenstein being conspicuous in this regard—rather than subjecting them to a "*détournement*" toward new, subversive content.

The actual effectiveness of these "deviated" comic strips in the pages of various Situationist journals can readily be debated. The Pop Art aesthetic, on the other hand, as embodied in the silkscreen medium and attention-getting blocks of bold color and type, fed the most successful and lasting artistic expression of the May 1968 events. Three of Hambourg's photographs (cat. 26–28) document the work of the Atelier populaire, a collective of students in the elite École des Beaux-Arts on the Left Bank who transformed their studios into a factory (the Warhol reference is apt) for the daily production of public posters.

One of these shows such a studio, temporarily unpopulated, with the customary canvases stored away out of reach, while the day's crop of drying posters hangs pinned to clotheslines strung throughout the space (fig. 4). The most legible of these declares "VIVRE et NON SURVIVRE" (LIVE and NOT [JUST] SURVIVE), a typical protest against what the students regarded as the deadening bureaucratic expediency imposed upon them by university

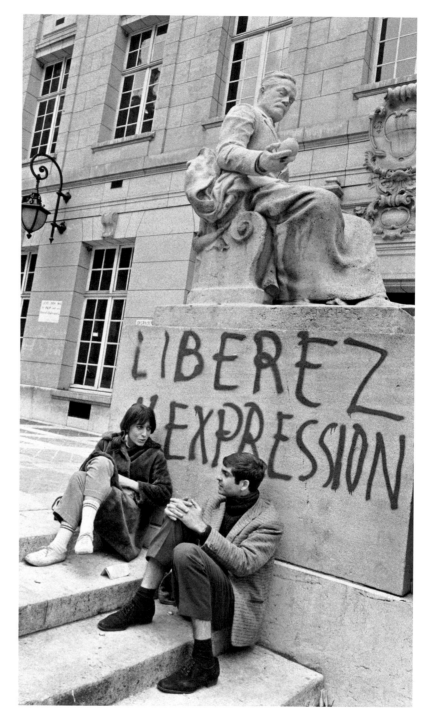

cat. 25. Two students at the Sorbonne sitting next to statue of Louis Pasteur with graffiti reading "Liberate Expression," May 1968.

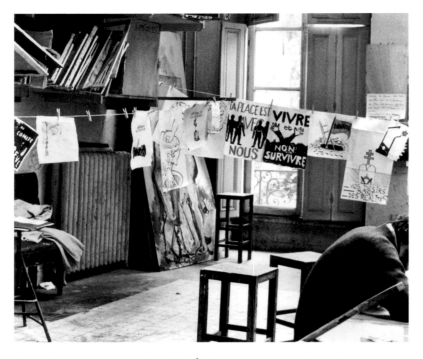

fig. 4. Posters hanging to dry at the École des Beaux-Arts, May 1968.

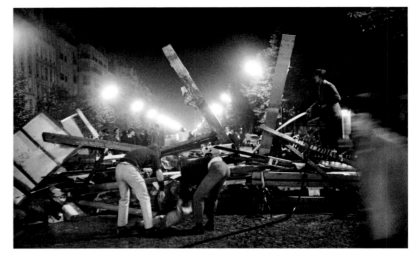

cat. 11. Building barricades at night, Latin Quarter, May 10–11, 1968.

structures and policies, one designed to prepare them for a future as obedient consumers and cogs in the capitalist machine. An enforced distinction between work (as regimented, monotonous) and leisure (as pleasurable, unconfined) constituted for them the most fundamental offense against the human spirit. Another poster made the point with even more memorable vividness: "SOUS LES PAVES LA PLAGE," which can be translated into English only by the awkward "UNDER THE PAVING STONES LIES THE BEACH." For the builders of barricades against the assaults of the national riot police (cat. 11), the old-fashioned cubic stones that paved the streets of central Paris (as seen up close in cat. 12) could be lifted from their beds of clean yellow sand with relative ease. While this was certainly of practical use, the revelation of the bright sands beneath also evoked the freedom of seaside holidays, conjuring a realm of imaginative possibility in the heart of the city.

Hambourg's photograph of the studio captures an exceptional moment, for the work spaces of the Atelier Populaire typically vi-

brated with activity around the clock. From the strategically located École des Beaux-Arts, students would fan out to post the latest posters on every available surface, their content calibrated to the hourly shifts in the state of the conflict (cat. 26). In the midst of their frenzied inventiveness as artists, members of the group issued the following statement of their aims: "The posters produced by the ATELIER POPULAIRE are weapons in the service of the struggle and are an inseparable part of it. Their rightful place is in the centers of conflict, that is to say, in the streets and on the walls of the Factories."[5] As the Hambourg photograph attests, these posters could not be removed without being destroyed in the process. Though their style and technique derive from gallery art, these dissident artists categorically rejected the idea that their anonymously produced, hit-and-run art events would have any use as objects of mere aesthetic contemplation (or indeed any form of retrospective display at all):

To use them for decorative purposes, to display them in bourgeois places of culture or to consider them as objects of aesthetic interest is to impair both their function and their effect. This is why the ATELIER POPULAIRE has always refused to put

them on sale. Even to keep them as historical evidence of a certain stage in the struggle is a betrayal, for the struggle itself is of such primary importance that the position of an "outside" observer is a fiction which inevitably plays into the hands of the Ruling Class.

As this statement makes plain, the conventional notion of a "pop" art preserves the essential traits of all decidedly non-popular art: an identified and admired individual maker along with the intention of prolonged contemplation and preservation. In seeking to understand the lessons of the Atelier populaire, we in the present historical moment have to violate the core precepts entailed in its practice. To see the many posters that survive framed on a white gallery wall is informative but deadened in precisely the way that their makers foresaw. The design quality of some surpasses others—catalogue number 28 captures the more grotesque and unsubtle end of the spectrum, revealing Hitler behind the mask of President Charles de Gaulle. But catalogue number 26 shows the degree to which such distinctions ceased to matter in the constantly changing welter of voices carried within the original short lives of the posters.

The mass protests of the current year make plain that an outward similarity of behavior can mask profound changes in the underlying structure of motivating ideas and aspirations. The manifesto of the Atelier populaire declares that their work "should not be taken as the final outcome of an experience." To see, via Hambourg's photographs, the posters of 1968 in their original time and place gives them a dimension of life that they no longer possess on their own, thereby rendering them as instructive and open-ended for the future as their makers intended.

NOTES

1. Jean-Luc Godard, interview from the film broadside *Kino-Praxis* (1968), quoted by Julia Lesage, "Godard and Gorin's Left Politics, 1967–1972," *Jump Cut* 28 (April 1983), pp. 51–58. Colin McCabe, *Godard: A Portrait of the Artist at 70* (New York: Farrar, Strauss, and Giroux, 2003), p. 399, notes: "It seems that Godard shot no footage of the riots. There is one famous image of him brandishing a super-8 camera, but he told Chris Marker that it had no film inside."

2. See Guy Debord, "For a Revolutionary Judgment of Art," in Ken Knabb, ed. and trans., *The Situationist International Anthology* (Berkeley: Bureau of Public Secrets, 2002), pp. 310–314.

3. See Andy Warhol and Pat Hackett, *Popism: The Warhol '60s* (New York: Harcourt Brace Jovanovich, 1980), pp. 113–114; also Victor Bockris, *The Life and Death of Andy Warhol* (New York: Bantam, 1989), pp. 167–168.

4. See Raoul Vienet, "The Situationists and the New Forms of Action against Politics and Art," in Knabb, *Situationist International Anthology*, pp. 213–215.

5. Anonymous, in *Posters from the Revolution, Paris, May 1968: Texts and Posters* (London: Dobson, 1969), colophon page.

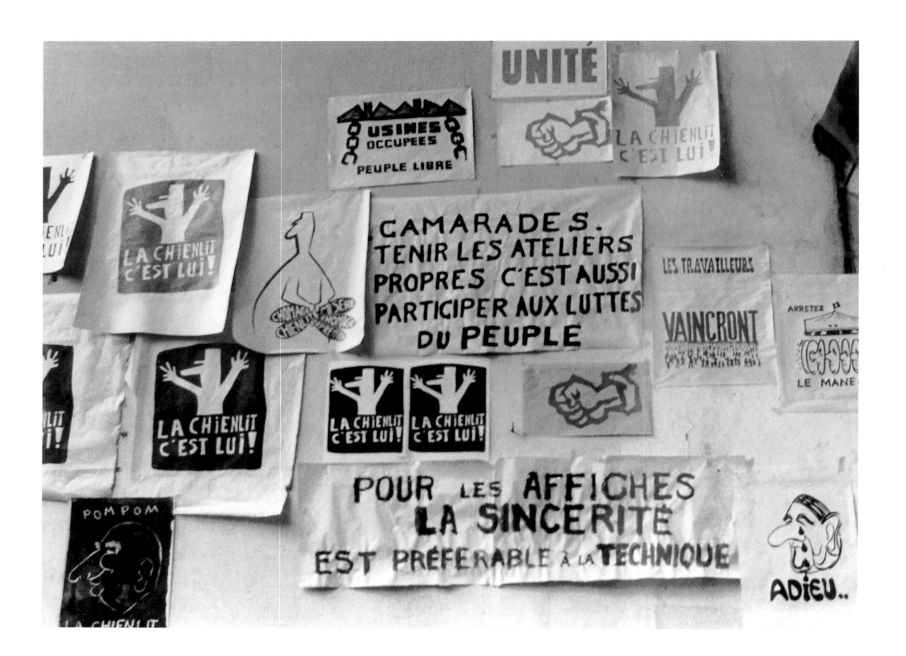

fig. 5. Posters at the École des Beaux-Arts.

22

Adieu: May 1968 as End and Beginning

ANNE SA'ADAH

Almost forty years later, May 1968 retains its ability to surprise, fascinate, and perhaps disturb observers. The "events"—as the monthlong wave of student and worker strikes and the attendant political crisis are known in France—marked a watershed moment in contemporary French social, political, and cultural history. Coming at the end of the postwar period of economic expansion, they expressed a nascent crisis of authority, identity, and representation. That crisis would soon be compounded by the economic and political changes we now associate with globalization, the disruptive effects of which have been particularly evident in the new millennium. As this exhibition was being assembled in the spring of 2006, young protesters were again in the streets. For a month and a half the Sorbonne was closed (as were many other universities), and the government's popularity ratings tumbled to unprecedented lows. Before the crisis of representation shared by both episodes became a standard feature of democratic politics, it was a French specialty.

In 1968 students and workers were never serious about overthrowing the Republic, even if many students were eager to play at revolution. Their parents had made wrenching choices in historically dramatic circumstances; the younger generation longed for a similar stage. "You, at our age," a protester told the dean of Nanterre, "you were in the war"; the dean, who had narrowly escaped deportation in 1944, thought the student lucky, but the student felt cheated by history.[1] Régis Debray (b. 1940), first on the admission lists of the prestigious Ecole normale in 1960, finished his studies in 1965 and soon left France to fight alongside Che Guevera in Latin America. In 1968, while his friends were building barricades in the Latin Quarter, Debray was sitting in a Bolivian jail. It was hardly a life of *métro, boulot, dodo* (the boring routine of commuting, work, and sleep), but still he was not satisfied. "I belong to a B generation," Debray wrote some thirty years later, "condemned by history to imitate the exceptional destinies of those who preceded us, taking all the great parts and leaving us to do the dubbing: imitation Blums, imitation de Gaulles, imitation Malraux, imitation Bernanos, imitation-whoever."[2]

The protesters mocked and defied a style of authority that they found stifling; it was life they wanted to change, not the government. The philosopher Jean-Paul Sartre (1905–1980), speaking on May 20 to a packed amphitheatre in the occupied Sorbonne, captured student sentiments, even if his words had an ironic edge: "I thought you were fed up with lectures"[3] (fig. 6). The contested style of authority—constitutive of relationships in family life, the school system, the workplace, and politics, and thus fundamental to the way people apprehended the social world in which they moved—never recovered. In the realm of private relationships, people defined new social roles and reached new arrangements.[4] But in the public sphere, the contestation added another layer of difficulty to democratic politics, even in the absence of an organized threat to the regime.

"There was obviously a problem in France at that time between young people and their elders," Nanterre's embittered former dean later remarked, but he also emphasized that institutional circumstances had aggravated the situation: "We were also handicapped by the absence of an active parliament, before which questions like those then current could have been brought."[5]

In the years that followed 1968, an impatience with centralized, "disciplinary" institutions of all sorts combined with the economic crisis to undermine the legitimacy and effectiveness of existing forms of representation, social integration, and collective action.[6] Institutional powerhouses like the French Communist Party (Parti

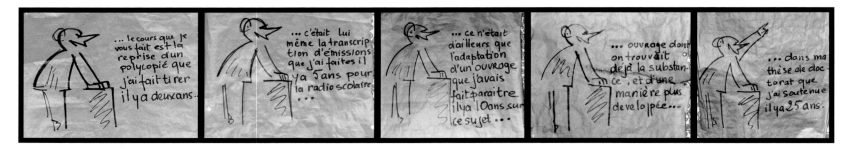

fig. 6. This anonymous 1968 graffiti drawn on a strip of brown paper reveals student dissatisfaction with a stagnant educational system. In a humorous series of vignettes, it shows a professor who has recycled his lecture numerous times and in effect has not changed its basic content for twenty-five years.

communiste français or PCF) declined; the trade union movement fragmented; the socialist party, painstakingly reconstructed in the 1970s after running aground during decolonization, went through repeated implosions. New organizations and patterns of social action recognized a new compartmentalization of social groups—immigrants, gays, women, undocumented aliens (*sans-papiers*), the unemployed, prison inmates. The deregulation of the airwaves and the advent of new forms of technology facilitated the emergence of more transitory and opportunistic forms of social cooperation, better suited to protest and resistance than to policy creation or political consolidation. Starting in the late 1980s, seemingly intractable high unemployment rates contributed to voter volatility and alienation. The centralized Jacobin state, which had been the mainstay of both the country's domestic order and its ability to project power internationally, was constantly challenged, by some for its arrogance and interventionism, by others for its impotence. Political reforms weakened authority without satisfying the demand for representation, while economic reforms neither proceeded from nor led to a new social contract. Elections produced no solutions. Meanwhile, a new international system reduced French power and influence in world affairs. Anguished debates about citizenship, identity, and sovereignty reinforced the general impression of a country in search of itself.[7]

Many people experienced that search as a decline—from social order, national and cultural greatness, prosperity, and certainty—and blamed France's downward slide on the nefarious effects of "May 1968."[8] This argument, problematic in several respects, suggests a discomfort with change and reform, yet change and reform were the main challenges of May 1968.

Explaining May 1968: International Perspectives

France was not the only country to experience unrest in 1968, nor is 1968 the only year in which street protests have suspended the normal course of French politics. The events of May 1968 can be portrayed as a relatively self-contained story, triggered by ongoing campus tensions early in the year at Nanterre (a new but already overcrowded satellite university hastily constructed on the outskirts of Paris; fig. 7) and ending with the crushing conservative victory in the rescheduled parliamentary elections of June. But the broader significance of the events can only be grasped if they are viewed in comparative terms—either synchronically but across space, or diachronically but limited to France. The self-understanding of contemporary actors was shaped by both forms of comparison.

Viewed synchronically, the events can be seen as part of a wave of unrest, often spearheaded by students, that affected a wide range of countries in the 1960s. Ideas circulated across borders; protesting students in different countries adopted common intellectual and political heroes. On May 9 and 10 the German refugee philosopher Herbert Marcuse, author of *One Dimensional Man* and a familiar reference among students at Berkeley, attended a

24

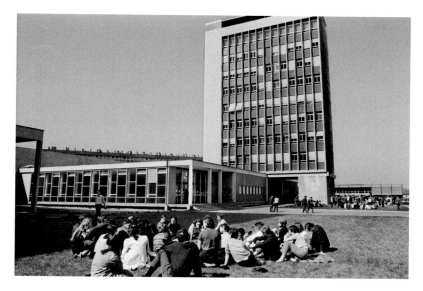

fig. 7. Nanterre University, March 1968.

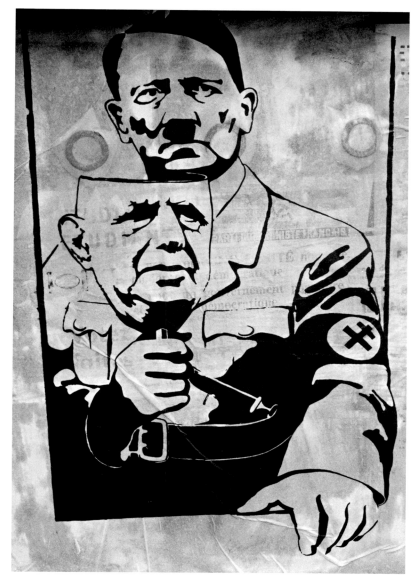

cat. 28. Poster showing Hitler with a de Gaulle mask, May 1968.

UNESCO conference in Paris marking the one hundred fiftieth anniversary of Marx's birth.[9] *Le Monde* published side-by-side interviews with Marcuse ("the leading intellectual light of angry students") and Norman Mailer, whose *Armies of the Night* had just been published in French under the title *Pourquoi sommes-nous au Vietnam?* The interviews appeared under the headline "Opulence on trial."[10]

Protesting students attacked the alleged hypocrisy and oppression of the social order in which they lived (whatever it happened to be); they criticized imperialism, capitalism, and bourgeois society; they were likely to be as vehement in their denunciation of established leftwing parties (including communist parties) as they were in their rejection of conservative parties; and they claimed to promote a new synthesis of freedom, socialism, personal autonomy, and internationalism.[11]

The students saw hypocrisy as the foundational principle of bourgeois society. Hypocrisy upheld bankrupt hierarchies and protected the "established disorder"; it substituted propriety and appearance for justice and self-fulfillment. French students reveled in displays of disrespect; they consistently indulged in verbal provocation and excess, which they preferred to lethal violence. An especially impudent poster attacked the president of the Republic: it portrayed Charles de Gaulle (1890–1970), the larger-than-life career officer who had refused to accept the finality of the 1940 defeat and had led the Free French through World War II, as a masked Hitler (cat. 28). In a society where young people were

expected to treat their elders with deference, graffiti scrawled on university walls dismissed professors as "old men."

In the lead-up to the May events, protests at Nanterre crystallized around two issues. One was sex; the other was Vietnam. During the 1960s, primary schools in France quite suddenly went coed.[12] While the initial moves were motivated by practical concerns, a sea-change in gender relations was underway. Among university students, sexual freedom—and pleasure more generally—became linked to authenticity. Students associated hypocrisy, discipline, and self-denial with order, and order with repression (political and sexual). They preferred authenticity and spontaneity, which they thought defined freedom.

The allergy to perceived hypocrisy and the critique of capitalism, imperialism, and bourgeois society were shared by student movements in several countries, notably by protesters in the United States and the Federal Republic of Germany. In other respects, however, the French events were distinctive.

First, with regard to causes, the French movement had few obvious prompts; just six weeks before the events, a well-known journalist, writing on the front page of the country's newspaper of record, worried that the country might "die of boredom";[13] on May 7, *Le Monde* noted that the "explosion of student anger has surprised all observers."[14] Despite scattered actions during the preceding year, the protests neither continued a prior movement nor focused on reversing a major public policy—whereas, in contrast, the contemporaneous American student movement drew on the struggle for civil rights and the legacy of the Berkeley Free Speech movement while targeting the Indochina policies of successive administrations.

Second, with regard to means, the near absence of lethal violence in France is extraordinary, especially given the length of the crisis (six weeks), the high levels of political tension and uncertainty, the constant confrontations between protesters and police, and the very considerable economic losses caused by the strikes. In the United States, student protests took place against a backdrop of continuing racial violence and nationally traumatic assassina-

tions and generated their own tragedies, symbolized by the Kent State killings of May 1970. In Germany, the police were unrepentant after a twenty-six-year-old student was killed by a point-blank shot to the head during a June 1967 demonstration.[15] On April 11, 1968, Rudi Dutschke, the leader of the West German Sozialistischer Deutscher Studentenbund (Association of German Socialist Students or SDS) was shot and nearly killed outside the organization's Berlin office by an assailant who had taken the virulent admonitions of the tabloid press too seriously. On the protesters' side, Action directe, an urban guerilla group active in France in the late 1970s and 1980s and remembered for the 1986 assassination of former Renault CEO Georges Besse, was not as integrally linked to the student movement as was the German Rote Armee Faktion (the Baader-Meinhof Group) and did not come close to matching the latter group's disruptive impact on mainstream political life.

Finally, with regard to goals and impact, the social breadth of the French movement was unusual, embracing intellectual elites, workers, and even peasants; Parisians and provincials; and young people and their sympathetic parents. Different participants were especially active at different moments in the crisis, and agendas varied. The sheer scale of the events suggested the depth and durability of the crisis and the complexities of its legacies despite the relatively rapid return to apparent normality that summer.

To get a better handle on the causes, course, and legacy of the events, therefore, we need to place them diachronically: as part of a French tradition of mass protest, and especially as part of a more specific postwar story of social change and complex political failure.

Explaining May 1968: French Antecedents

The French have a long and rich tradition of mass protest, and the protesters of May 1968 drew on the repertoire it provided. Substantively, however, the events marked the end of that tradition. The great *journées* of the revolutionary period (of which the most famous toppled the monarchy on August 10, 1792), the insurrec-

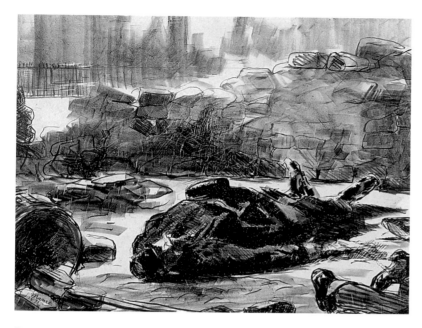

fig. 8. Edouard Manet, French, 1832–1883, *Civil War (Guerre Civile)*, 1871, lithograph on wove paper. Purchased through the Julia L. Whittier Fund; PR.955.110

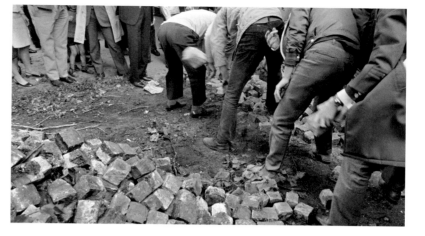

cat. 12. Building barricades near the Sorbonne University, May 10, 1968.

tionary riots of July 1830, the June Days of 1848, the Paris Commune of 1871 (fig. 8), the rightwing riots of February 6, 1934, and the sitdown strikes of 1936 were all expressions of profound ideological and/or class conflict. Typically, mass protest threatened the regime in power and often led to its downfall. Because power was concentrated in Paris, so too were the protests. Men died on barricades constructed for military purposes, and they also died afterward, as the victorious side settled accounts.

In the standard narrative of May 1968, the night of May 10 is known as the *nuit des barricades*.[16] Students in Paris used uprooted trees, overturned cars, and paving stones to erect barricades in the Latin Quarter (fig. 9 and cat. 12). The proximate cause of the action was the violation of student space by the police. Universities informally expected the immunities formally granted to parliamentary bodies and churches. On May 3, however, the rector of

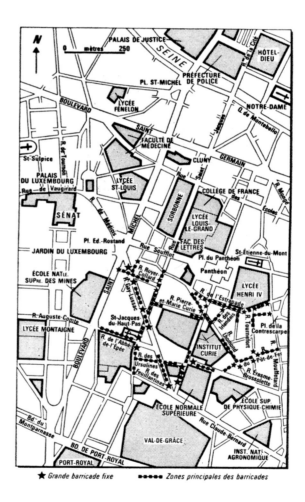

fig. 9. Map from the May 12–13 issue of *Le Monde* showing the location of the barricades in May 1968.

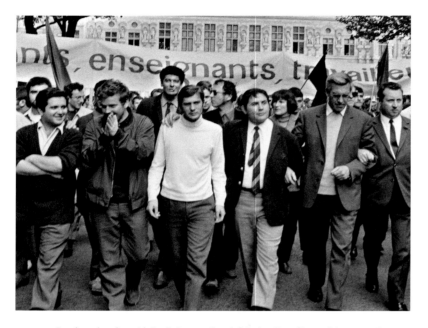

cat. 16. Student leaders Alain Geismar, Daniel Cohn-Bendit, and Jacques Sauvageot march together during student/worker demonstration, March 13, 1968.

the Sorbonne, the biologist Jean Roche (1901–1992), asked the police to clear protesting students out of the university courtyard.[17] Exiting students, including several of the Nanterre *enragés,* were steered straight into waiting police vans. The intrusion of the police, coupled with the sentences meted out to several students who had been arrested during the police action, quickly transformed a limited protest into a mass movement. One week later, perceived police brutality during the *nuit des barricades* in turn triggered a general strike by the unions, and that strike threw the country into an increasingly unsettling political crisis.

The form of the protest was imitative of insurrections past, but its substance was not. The barricades thrown up on the rue Gay-Lussac and the violence elsewhere on the night of May 10 were not part of any coherent plan, formal or informal, to retake and hold the Latin Quarter, much less to overthrow the government; they were intended (and used) simply as points of confrontation between protesters and "occupying" police units. The violence was often intense and hundreds of people were injured, but no shots

were fired that night and no lives were lost. Literally as well as figuratively, neither side was properly dressed for combat (cat. 16). "Put imagination in charge!" and "Be realists, demand the impossible!" were, in their own way, revolutionary slogans, but they were quite different from "Down with the Republic!" Even later in the month, the students never threatened the Elysée Palace or the Hôtel Matignon (the seats of the president and the prime minister, respectively), nor did they attack the Ministry of the Interior; in fact, the prefect of police, Maurice Grimaud, circulated unmolested throughout the days and nights of the crisis, and the Ministry of Justice was unguarded.[18] In schools (including the Sorbonne, which was abandoned to students on May 13), factories, and public squares all over France, what strikers seized was the opportunity to converse and discuss, not the government ministries or banks or army barracks. Police Prefect Grimaud was almost obsessive in his determination to avoid the loss of life.[19]

Under other circumstances, troops might have been called on to shoot protesters or replace strikers. As recently as October 1961, a demonstration in Paris had ended in blood; some two hundred people had been shot, drowned, or beaten to death by the police.[20] Only six years before the events (in August 1962), a politically motivated attempt on de Gaulle's life had narrowly failed.[21] Yet in 1968 the government never officially mobilized the army,[22] nor did it use Article 16 of the French Constitution to declare a state of emergency, despite the fact that not just Paris but the whole nation was engulfed by the protests. On the tense night of May 24, when students in Paris did attack the Bourse (the stock exchange), Minister of the Interior (and former education minister) Christian Fouchet kept his head: "A victory bought with blood would be a defeat."[23] Georges Pompidou, the prime minister, was categorical: "I won't have any shooting."[24]

Thus while the barricades of May 1968 seem to recall France's ideologically polarized and politically unstable past, closer examination suggests not just the differences with other countries experiencing unrest in 1968 but a departure from past patterns of French protest as well. Between the end of the Algerian War in 1962 and

the events of 1968, France moved from regime-threatening polarization to democratic discontent. On May 30, 1968, when Jacques Chaban-Delmas read the presidential decree dissolving the National Assembly, *both* sides of the chamber responded by singing the *Marseillaise*.[25] Had the government disintegrated in 1968, the successor regime to the ten-year-old Fifth Republic would most likely have been . . . a Sixth Republic. Dramatic forms of protest remained deeply rooted in identifiable political and social conditions, but despite the overheated rhetoric of late May and the first weeks of June, seemingly radical protest had ceased to sustain an alternative political project. Then, as now, democratic politics-as-usual might be experienced as profoundly unsatisfactory, even beyond repair, but short of demanding the impossible, no one has an alternative.

Actors, Issues, and the Problem of Reform

The stage on which the May 1968 drama played was set by postwar social change and by the institutional changes implemented when the Fifth Republic was created in 1958. The main actors in the national drama included students, workers, and the president of the Republic, Charles de Gaulle. Other social groups served quite literally as the chorus; the country as a whole weighed in as the crisis came to an end. On May 30, de Gaulle invoked his powers under Article 12 of the Constitution and dissolved the National Assembly. On June 23 and 30, the electorate went to the polls and returned a massive conservative majority. But in April 1969, de Gaulle, again using the constitutional powers granted him by a constitution he had crafted, called a national referendum: against the wishes of the protesters, he had remained in power; against the wishes of his supposed supporters, he wanted reform. When his proposals were defeated, he issued a two-line communiqué and cleared his desk. Some of the more innocuous slogans brandished by the protesters of 1968 had alluded to de Gaulle's seemingly unending presence: "Adieu" (see essay frontispiece), "Ten years is enough," "De Gaulle in the filing cabinet."[26] Just short of the eleventh anniversary of his

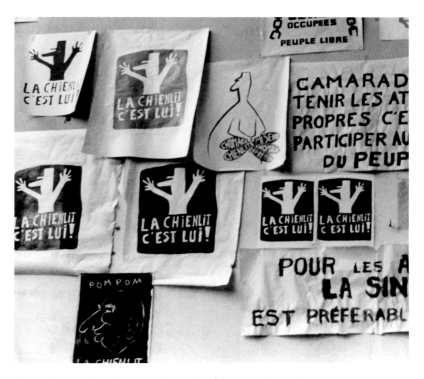

fig. 10. Posters hanging in atelier at the École des Beaux-Arts.

return to power, de Gaulle was gone. Another widely reproduced poster reversed the object of a vulgar insult de Gaulle had directed against his young critics: "La chienlit," the poster proclaimed, "c'est lui" (fig. 10). What the General (as he was always called, in acknowledgment not of his military rank but of his wartime role) had actually said was "La réforme, oui; la chienlit, non."[27]

De Gaulle made another much remembered remark about reform, this one in response to Raymond Aron (1905–1983), the sociologist and student of Alexis de Tocqueville. Aron had claimed that "From time to time, France has a revolution, but it never engages in reform." De Gaulle retorted: "France only engages in reform in the aftermath of a revolution."[28] *Chienlit*, revolution, reform: all suggest ways of thinking about the challenges represented by May 1968. The results of the June parliamentary elections suggested that many people shared, or came around to, de Gaulle's view of the protests as verging unacceptably on anarchy. But reform was the

word on everyone's lips—not just specific reforms, but the problem of reform in general. Whether May 1968 was a revolution or a *chienlit*, questions remain about its effects on the prospects for reform.

The students who revolted were in every sense a product of postwar social change—change so significant and multifaceted that it is often described as a revolution.[29] The students' numbers were unprecedented, and so were their opportunities. Between 1946 and 1968, France's long-stagnant population increased from roughly forty million to fifty million. Between 1946 and 1950, the average number of births jumped to 860,000 per year, up from 690,000 between 1931 and 1935 and 620,000 during the last years of peace.[30] Between 1950 and 1968, the standard of living doubled.[31] The unemployment rate in 1968 was 2.7 percent; for most of the 1960s, it was under 2 percent.[32] The protesters' parents, born in the first decades of the twentieth century, had come of age in a world marked by war and economic insecurity. They had feared, worked, and saved. They had also hoped, as the rising birth rate suggested. Their heightened aspirations increased the social demand for education.

The baby-boomers soon flooded the school system. The Third Republic (1875–1940) had made primary education—free, secular, and compulsory, as its proponents constantly insisted—an instrument of national integration and a bulwark against the republic's monarchist and clerical enemies. In contrast, secondary and postsecondary education had remained the preserve of that small portion of the population able to pay the fees, postpone entry into the workforce, and master classical Greek. In 1936, when the newly elected Popular Front government raised the school-leaving age from thirteen to fourteen, approximately fifty thousand students were enrolled in French universities. In 1949–50, approximately 137,000 students were at university; under 5 percent of an age cohort could be expected to pass the *baccalauréat* exams. In 1959 the government raised the school-leaving age for children born after January 1, 1953, to sixteen, even as the Algerian War (1954–1962) restricted the resources available to expand and modernize the school system. In 1960, about 215,000 students were at university.

In 1967–68, 508,000 students were at university; in the late 1960s, the proportion of an age cohort reaching the *baccalauréat* level had climbed to about 15 percent.[33] In 1947–48, 102,000 students were attending state schools at the secondary level; in 1957–58, there were 175,000, and in the academic year interrupted by the May events, 422,000.[34] During the May 1968 events, about 160,000 university students were studying in Paris.[35]

Prior to the decentralization reforms of the 1980s, education was the responsibility of the national government, which had authority over both capital investments and pedagogical decisions. The expanding school population created three challenges, faced successively—but with very incomplete success—by the governments of the Fourth and Fifth Republics. The policy record helped set up May 1968. First and most obviously, the new expectations suggested an urgent need for more classrooms and better facilities. Secondly and less visibly, the rapid expansion of the school system had a significant impact on age and rank distributions within the professorial corps and raised divisive issues about teacher training and hierarchies within the profession. Lastly, the "massification" of education called for the thorough reconceptualization of a system that had been designed for an elite: what tracks would be offered, how would students be guided in their choices, and what mechanisms of selection would be adopted? The latter two questions were especially inflammatory: they made the quest for social mobility and inclusion dependent on the performance of the school system, and they would continue to plague governments for decades after 1968.

Under the Fourth Republic, government promises to increase the ministry of education's budget were compromised both by the continuing costs of the Algerian War and by construction bottlenecks that prevented the ministry from actually spending the funds allocated for capital projects. Under the Fifth Republic, the government was better positioned to put its resources where its rhetoric was, and the money began to flow: education accounted for 8.03 percent of public expenditures in 1957 (approximately 2 percent of GDP); by 1965, that figure had jumped to 16.33 percent (approxi-

mately 3 percent of GDP).[36] In 1939, France had counted twenty-four cities with universities; by 1968, there were forty.[37] Much of the new construction was unattractive, of dubious quality, and designed without particular attention to the relationship between form and function. The real problems, however, lay elsewhere.

As the student population ballooned, the state hired more teachers at every level. Despite these spectacular increases, however, the hiring did not keep pace with the changing needs of the student population.[38] Nor had the necessary administrative adjustments occurred:

The growth of the educational system occurred within an unchanged administrative structure, similar to an army that tripled its manpower without tripling its number of regiments, or a city that doubled in population without opening an additional post office or an administrative annex. A *lycée* of 500 students included a principal, a dean of students, and a faculty room; with 1,500 students, our *lycées* still had a single principal, a single dean of students, and just one faculty room. The notion that an institution constitutes an organic whole and that it might come apart if pushed beyond a certain threshold unless it is restructured along different lines, this piece of common sense . . . is not accepted by the educational bureaucracy.[39]

Policy was, of course, not made in a vacuum. Both students and the professorial corps had developed organizations to represent their interests, and in various ways these organizations helped set the stage for, and then became participants in, the events of May 1968.

The main student organization, the Union nationale des étudiants de France (National Union of Students or UNEF), was handicapped by the inevitable turnover of its leadership cadres. More importantly, its membership shared a corporate identity but included students of different political persuasions. If the future socialist prime minister, Michel Rocard, was once a UNEF leader, the future standard bearer of the extreme right, Jean-Marie Le Pen,

was far more active and prominent in student politics. In moments of high political tension, the UNEF's political diversity made the organization prone to paralysis, schism, or both.[40]

The UNEF regularly demanded universal student stipends. It promoted the development of student cafeterias and the involvement of students in overseeing student housing. It invested in the printing and distribution of *polycopiés*, reproducing the lectures that professors would repeat year after year to increasingly crowded lecture halls, and that the protesters of 1968 would deride. Under the Fourth Republic, the UNEF was an important player in governmental discussions regarding educational policy. It was also partially funded by the government, which accepted its claim to speak for all French students.

Local or school-specific branches of the UNEF sometimes had particular political leanings, but the organization as a whole remained resolutely independent of France's many political parties. The UNEF's so-called majority interpreted this independence as committing the organization to an apolitical, corporatist posture. In practice, the "majos" were often politically conservative. In contrast, the so-called minority, which gained a precarious hold on leadership positions in 1956 (but retained its "minority" label), argued that the UNEF's partisan independence did not mean that the organization should remain neutral on key political issues. In the mid-1950s, the paramount political issue was the war in Algeria. The expansion of the war had taken place under a socialist-led government, yet most of the growing opposition to the war came from people who normally voted for the left. Many felt politically stranded: the country was in crisis, and no major party represented their views. The small Parti socialiste unifié (PSU) gave leftist opponents of the war a place to congregate, but it was far too small and too ideologically diverse to serve as an effective political instrument. Its members—typically young, highly educated, and committed to decolonization—were generally on their way to other political destinations. Many admired Pierre Mendès France (1907–1982), an independent leftist politician who, as premier in 1954–1955, had extricated the French from Indochina and then

tried—unsuccessfully—to give the Fourth Republic a democratic backbone, in the form of an organized, principled, electorally powerful reformist party.[41] As a former *résistant*, Mendès had an ineradicable respect for General de Gaulle, but he rejected the institutions of the Fifth Republic as an invitation to Bonapartist authoritarianism. From the party's creation in 1960 until the summer of 1968, Mendès was himself a member of the PSU.

The war affected students directly because of conscription. It also challenged the UNEF as an organization, because Muslim Algerian students quickly became targets of police attention and because in Algiers the European and Muslim branches of the student movement reacted in diametrically opposed ways to the war. At the price of endless debates and two splits (in 1957 and 1961), the UNEF became an important institutional critic of French policy in Algeria: it urged a negotiated end to the war and condemned the use of torture by French troops. In 1960 the UNEF could claim the adhesion of one out of every two French students (in contrast, the rate of unionization among workers was under 25 percent).[42] The government slashed its subsidy and, in 1961, sponsored the creation of a rival organization (still marginally active in 1968), but the UNEF held its own.

The UNEF's glory days ended with the conclusion of the Algerian War in the spring of 1962. Over the next few years, the organization struggled unsuccessfully with substantive and organizational difficulties. Substantively, no public issue similar in magnitude to the Algerian War could provide politically minded students with a focal point for mobilization. At the same time, the organization's effectiveness as a pressure group articulating and defending the specific interests of French students was compromised by the institutional innovations of the Fifth Republic. The new republic's strengthened executive was intentionally more autonomous than had been the decision-making processes of the parliamentary Fourth Republic. In 1968 the regime would discover the costs of neglecting lines of communication with a significant segment of society, but in the meantime UNEF's access and influence declined.

Organizationally, the UNEF suffered from an evaporating leadership pool. In the 1950s it had drawn on the leadership skills of young people who had come through the ranks of the then-vibrant Catholic youth movements. The Association catholique de la jeunesse française had created socially specialized branches in the 1920s, including one for students (the Jeunesse étudiante chrétienne or JEC). The movements produced a generation of young activists whose abilities and experience left a profound mark on French society. Former youth activists played key roles in the Resistance, the briefly prominent postwar Christian democratic party, and worker and peasant organizations. *Jécistes* arrived at university motivated by an ethos of service and, because the JEC organized secondary school students as well as university students, tempered by prior activist experience; many of them in turn held influential positions in the UNEF between 1956 and 1962. At the same time, however, the JEC itself went into crisis, prompted in part by tensions with the Catholic hierarchy. By the late 1960s the JEC could no longer serve as a leadership school for the UNEF.

The young communists—organized as the Union des étudiants communistes (UEC)—briefly provided the UNEF with an alternative source of leadership. But they too were in conflict with their parent organization and in search of new ideas and new forms of action. They were also more divided amongst themselves and more marginal within the UNEF than the JEC leaders had been. By 1968, the French Communist Party (PCF) had clamped down on the UEC, whose more dynamic members had either left or been thrown out. Among them was Bernard Kouchner (b. 1939), a friend of Debray's, a veteran of anticolonial activism, and the future founder of Doctors without Borders.

By the mid-1960s the UNEF, politically fractured and ineffectively led by students affiliated with PSU, crippled by continuing financial problems, and supported by perhaps one student in ten,[43] could no longer even sustain its own publications. In April 1968 the UNEF's outgoing president left office without a replacement. For the first several days of May, *Le Monde*, France's newspaper of record, referred to the UNEF's temporary leader as Marc Sauva-

geot.[44] When he appeared in the courtyard of the Sorbonne on May 3, more credentialed activists asked who he was.[45] Jacques Sauvageot (cat. 17), a twenty-five-year-old graduate student in art history, could not have imagined how eventful his interim presidency was about to be.[46]

Within and especially outside the UNEF, "hard left" activists were forming small, sectarian cells known as "miniscule groups," or *groupuscules*. They drew their inspiration from the assassinated dissident Bolshevik Leon Trotsky (1879–1940) and/or the Chinese Communist leader Mao Zedong (1893–1976); some also dabbled in psychoanalytic theory, exploring the ideas of Wilhelm Reich (1897–1957) and discovering Jacques Lacan (1901–1981).

For years, rival Trotskyite groups had attracted leftwing activists impatient with the PCF's intellectual rigidity, organizational discipline, and political opportunism; many Trotskyites were former communists, while others operated as moles within the PCF. Trotskyites had been especially efficacious in providing clandestine assistance to the National Liberation Front during the Algerian War.

Maoism was likewise attractive to the PCF's leftwing critics. From the late 1950s on, the Sino-Soviet conflict highlighted the differences between the rival communist regimes. While the PCF had a long history of following Moscow's lead, its youthful critics, often focused on anticolonial and Third World issues, saw little to admire in the Soviet regime. Instead, they were fascinated by Maoist doctrines of guerilla war and popular struggle, and by the Great Proletarian Cultural Revolution initiated by the Chinese leader in 1966.

Most *groupuscules* were ephemeral, but a few were less so, and several important figures in the May 1968 drama came from their ranks. In the spring of 1966, Alain Krivine (b. 1941), a recent exile from the PCF, a veteran of Algerian War–era struggles, and already a longtime Trotskyite activist (and friend of Kouchner and Debray), created the Jeunesse communiste révolutionnaire (JCR); it would be banned by the government in June 1968 but would reemerge in 1974 as the Ligue communiste révolutionnaire (LCR), becoming a fixture of French politics.

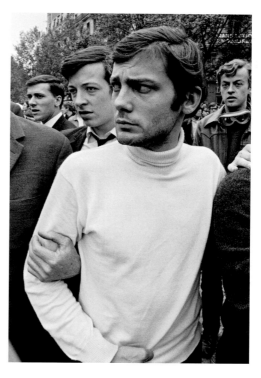

cat. 17. Student leader Jacques Sauvageot at demonstration, May 13, 1968.

Like the Trotskyites, the Maoists had more than one political outlet from which to choose. In November 1966 dissident ex-members of the UEC, many of them students at the ultra-elite Ecole normale, formed the Maoist Union des jeunesses communistes— marxiste-léniniste (UJC-ML) and dreamed of taking their fervor into the factories; the group would be banned by the government in June 1968. Ex–UJC-ML activists later created La gauche prolétarienne. Serge July, a UNEF vice-president in 1965 and, several years later, one of the founders of the influential Paris daily *Libération*, followed this Maoist itinerary.

In the same month that saw the birth of the UJC-ML, Situationists took over the local UNEF branch in Strasbourg. Their express intention—quickly achieved—was to destroy the branch (such as it was). The Situationists drew on a political tradition critical of all forms of modern bureaucratic rule, whether capitalist or socialist.[47] They believed in creating situations so as not to be shaped

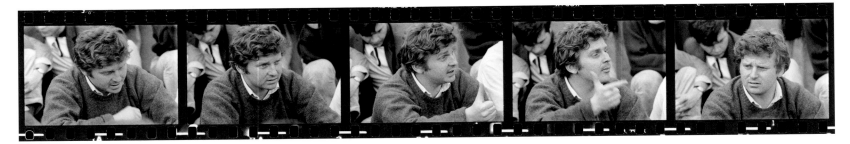

fig. 11. Daniel Cohn-Bendit speaking to students at Nanterre University, March 1968.

by situations others had already created. Taking their critique of bureaucracy to the extreme, they rejected all rules and structures as oppressive, favoring a politics of insolence, insult, and exclusion. The pamphlet published in 1966 by the Strasbourg group—significantly if tediously entitled "De la misère en milieu étudiant considérée sous ses aspects économique, politique, psychologique, sexuel et notamment intellectuel, et de quelques moyens pour y remédier"—made its way to Nanterre. The ex-communist philosopher and sociologist Henri Lefebvre (1901–1991), on the faculty at Strasbourg until his appointment in 1965 at Nanterre, served as a conduit for Situationist ideas and soon became the main faculty apologist for radical students at Nanterre. Anarchist groups adopted the Situationists' emphasis on spontaneity and elevated insolence into a primary means of political action.[48]

Groupuscules staking out territory ostensibly to the left of the communist party did not have a monopoly on the turbulent student political scene; the extreme right was also active. The late winter of 1964 saw the creation of Occident, which was loosely descended from a prior group that had carried out a bomb and assassination campaign in an unsuccessful effort to stop decolonization in Algeria. Occident was a proto-fascist organization: it wanted to restore national "greatness" by ridding France of republican government, universal suffrage, racial mixing, and corrupt values. Its founding members included Gérard Longuet (b. 1946) and Alain Madelin (b. 1946); both would serve as ministers in conservative governments following the 1986 and 1993 elections. Occident sought out physical confrontations with *groupuscules* on the

left, which often returned the favor; both sides took to equipping themselves with helmets and clubs. The government banned Occident in November 1968; it quickly reemerged as Groupe union droit and then Ordre nouveau.[49] From the early 1980s on, it was eclipsed by Le Pen's Front national.

None of the student groups discussed above planned or "led" the student strikes of May 1968, and the "fascists" of Occident, despite violent raids and small demonstrations throughout the events, neither significantly aggravated the unrest nor knew how to exploit it with the ruthlessness of real fascists. All told, in May 1968 the leftwing *groupuscules* could claim somewhere between five thousand and sixteen thousand adherents;[50] Occident may have had several hundred members.[51] The energy behind the strikes came not from conspiratorial activity but from underlying conditions. As the demonstrations grew increasingly massive, student slogans ridiculed both government contentions that a handful of students was stirring up trouble (in a sea of demonstrators, placards were raised saying: "Nous sommes un groupuscule!" and "Une dizaine d'enragés!") and the government's claim to represent the country ("UNR-groupuscule").[52]

In the absence of strong organizations, leadership mattered. Daniel Cohn-Bendit (b. 1945; fig. 11), the most prominent and memorable student leader from 1968, had been—but was no longer—a member of the UNEF. Cohn-Bendit, the French-born son of German Jewish refugees, was a sociology student at Nanterre. Among Nanterre's eleven thousand students, a mere five hundred belonged to the UNEF.[53] Cohn-Bendit was, both formally and in-

formally, an anarchist; described by Nanterre's dean as an "orator who used rich imagery, indignant, quick to laugh, accusatory,"[54] the charismatic young redhead was allergic to authority. He had completed his secondary schooling in Germany, accepted German citizenship so as not to be drafted (as a Jew, he was exempt from conscription in the Federal Republic), and was in contact with the Berlin SDS. He skirmished with school authorities in 1967 over the issue of coed access to girls' dormitories and created an incident in January 1968 by asking the minister of youth and sports why his *Livre blanc sur la jeunesse* failed to mention the sexual problems of young people.[55] Two months later, Cohn-Bendit and fellow members of the newly founded anarchist Mouvement du 22 mars occupied the highrise that housed Nanterre's administrative offices. They were protesting both the arrest of students who had staged an attack two days earlier on the Paris offices of American Express to protest the Vietnam War and the kind of education on offer at the university. The occupation led to disciplinary proceedings and was, in effect, the inaugural event of "May 1968."

During the first weeks of protest, Cohn-Bendit was constantly present. Then, over the weekend of May 18–19, apparently exhausted, he left first Paris (visiting his brother and speaking at a demonstration in the Atlantic port city of Saint-Nazaire) and then the country. At a rally in Amsterdam, he suggested ripping up the French blue-white-red *tricolore* in order to make a red flag. The French government used the event as a pretext to revoke Cohn-Bendit's residence permit. Cohn-Bendit's Paris comrades now had a new slogan: "We are all German Jews." When the banished leader resurfaced—as he had promised he would—on May 28 in the occupied Sorbonne (his hair dyed, and wearing dark glasses), the government looked impotent as well as ugly.[56] But by then Cohn-Bendit had been superseded; mainstream politicians and trade unionists were suggesting alternatives to "spontaneity," and the initiative was about to revert to the political right. In June, Cohn-Bendit would return to Germany. In Frankfurt, he moved in the same anarchist ("alternative") circles as Joschka Fischer, the future Green politician and German foreign minister. In the European

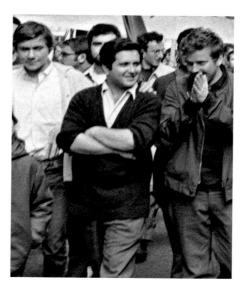

fig. 12. Alain Geismar marching on May 13 (detail of cat. 16).

Parliament elections of 1999, Cohn-Bendit led the French Greens to their best-ever results (9.7 percent). In 2005 he campaigned in favor of the proposed European Constitution.[57]

Alain Geismar, another prominent figure in the May events, was not a student at all (fig. 12; see also cat. 16). In 1968, Geismar (b. 1939) was a young physics professor in Paris and the newly elected head of SNE-Sup (Syndicat national de l'enseignement supérieur), one of the smaller teachers' unions within the large and powerful Fédération de l'éducation nationale (FEN).[58] SNE-Sup was particularly strong among junior faculty in the sciences, where the ratio of junior to senior faculty had gone from 1,020 to 2,574 in 1960–61 to 1,914 to 7,596 in 1967–68.[59] Many of SNE-Sup's members were communists; they tended to want the union to confine itself to the problems of the academy, so as not to compete with the party's leadership role in politics. Geismar, in contrast, was (like Sauvageot) a member of the PSU and less inclined to separate issues of university reform and resources from broader political questions. He had won his leadership position on the basis of a program entitled "For a small cultural revolution in the University."[60] As a student activist, he had opposed the Algerian War.

Under Geismar's leadership, SNE-Sup took immediate exception to Dean Pierre Grappin's decision to close Nanterre, as well as

to the disciplinary action initiated against Cohn-Bendit and five of his fellow activists.[61] On May 4, after the arrests, demonstrations, and violence that followed the evacuation of the Sorbonne, SNE-Sup called on its members to strike. Throughout the month, SNE-Sup worked closely with the UNEF. Both groups walked a fine line, seeking simultaneously to energize the protesters and to avoid an escalation into lethal violence.[62] As a graduate of a prestigious engineering school and the head of SNE-Sup, Geismar had adult status and access to establishment figures. But the May events had a radicalizing impact on him. On May 27, after a series of contradictory votes at a union convention, Geismar resigned his position as head of SNE-Sup so as not to be constrained by his representative function.[63] During the months that followed the spring of 1968, Geismar would become a leader of the Maoist group La gauche prolétarienne. The group was banned in May 1970; Geismar was arrested in June, tried in October and November, and released a year later, in December 1971. In the 1990s, Geismar served on the staffs of several successive socialist ministers of education.

The FEN supported protesting students and workers during the events, but more hesitantly than did its member organization, SNE-Sup. In the lead-up to 1968, the FEN's problems were the opposite of those faced by the UNEF: the FEN's constituency—which included elementary school teachers as well as secondary school and university professors—was unanimous in its support for the political left but deeply divided in its corporate interests. As a result, it could neither generate consensual proposals for educational reform nor provide cover for a government that might initiate such reform.

The two largest and most influential organizations within the FEN reflected the bifurcated structure of France's public educational system. Prior to the reforms adopted under the Fifth Republic, that system was anchored by two institutions: the *école primaire* and the *lycée*. Each delivered a particular kind of education to a socially specific audience; the teaching corps associated with each branch was likewise distinct. The *écoles primaires* addressed the putative educational needs of children who were not expected to remain in school beyond the statutory school-leaving age. They were staffed by *instituteurs* who themselves had gone straight from an *école primaire supérieure* to a teacher training school (*école normale*)—that is, who had not attended a *lycée* or obtained a *baccalauréat*.

While the *école primaire*, increasingly extended by a few years of additional education, defined the educational universe in which most French children moved, the children of privilege walked in a different world. They did their *petites classes* (early grades) in the *lycées*. They followed a curriculum different from that used in the *écoles primaires* and began Latin in the *6ᵉ*, at age eleven. The *lycées* prepared students for the *baccalauréat*, after which successful candidates might go on to a *grande école* (specialized schools whose students were selected through highly competitive national *concours*) or to university. *Lycée* teachers were *bacheliers* who had subsequently specialized in a particular field and passed rigorous oral and written examinations: they typically held a CAPES (*certificat d'aptitude pédagogique à l'enseignement secondaire*) or less commonly had passed the more prestigious *agrégation*.

Faced with exploding numbers of students and obsessed with *grandeur* (national rank) and economic growth, the Fifth Republic was determined to reshape the school system, opening it up so as to develop the country's human resources and redirecting students toward areas useful to an industrial economy. In the ensuing policy debates, the Syndicat national des instituteurs (SNI), long dominant within the FEN, represented school teachers; the smaller Syndicat national de l'enseignement secondaire (SNES) represented *lycée* professors. The two groups had substantially different positions, perceptions, and preferences. No government seemed able to get beyond their disagreements, except by avoiding fundamental questions about educational content, methods, and—above all—tracking and selection. The usual stumbling block was the Latin requirement, considered fundamental to a *lycée* education.

Reforms were adopted—notably in 1959, 1963, 1965, and 1966—but they skirted the most difficult questions. Politically, the only part of the reform program that was obviously viable was

the commitment to "democratize" the system; moves to track and select students encountered immediate resistance.

Nanterre exemplified the difficulties that had accompanied the expanded reach of the educational system. The new university complex was constructed from scratch on a piece of property no longer needed by the air force. The lone *métro* stop serving the site was inauspiciously called "la Folie" (the word for insanity). The surrounding land was covered with shanties that sheltered immigrant workers. The decision to build Nanterre was made in 1963; the university welcomed its first students on November 2, 1964, with construction still underway. The buildings were characterless; several lecture halls had no windows. Twelve professors had been seconded from the Sorbonne. The dean, Pierre Grappin, was a Germanist, progressive in both his politics and his pedagogical views. The door to his ground-floor office was always open.

Enrollments at Nanterre doubled annually; more characterless buildings were completed; the dean's office was relocated to a less accessible upper floor.

In 1966, reforms initiated by Minister of Education Christian Fouchet took effect, partially reconfiguring university degree possibilities and requirements. The government abolished the introductory year (*propédeutique*), which incoming students had previously used to consider possible fields of specialization. A three-year program with little flexibility replaced a system in which students had obtained their first university degree by earning four field certificates. Dean Grappin was at a loss to identify how the new system constituted an improvement over the old. Nanterre now had 5,700 students.

In March 1967 a group of boys, led by a not yet famous redheaded sociology student, occupied a girls' dorm. The next month, the outgoing Minister Fouchet advised Dean Grappin to abandon Nanterre and accept a safer position as rector at Nancy. Grappin declined. In the fall of 1967 enrollments at the new (and still unfinished) university again doubled, and political incidents began to multiply. In December 1967 the dean could still command the attention of a meeting attended by two thousand students. In February 1968, however, the former *résistant* emerged from a lecture to find himself "face to face with a sort of poster booth, featuring the slogan: 'GRAPPIN = NAZI = S.S.'"[64] By early May, when snowballing events caught other people in positions of responsibility by surprise, the beleaguered, discouraged dean of Nanterre was already exhausted.

Until mid-May, the demands of the protesting students were largely reactive. In statement after statement, Sauvageot, Geismar, and Cohn-Bendit demanded the dropping of charges against students, the withdrawal of police units from the Latin Quarter, and the reopening of closed universities. The most common slogans were "Free our comrades!" and "The Sorbonne belongs to its students!" Even during this first period, however, the protesters threatened to boycott or disrupt examinations—while the authorities insisted that examinations would be held on schedule (most were not). Examinations, along with formal lecture courses, were the central institutions of the university system. As the protesters moved from reactive anger to utopian speculation, they tried to imagine a world in which neither examinations nor *cours magistraux* would exist.

* * *

Students were only half the story in May 1968—chronologically, the first half. Beginning on May 14, the working class joined the fray; by May 20, the country's economy was at a standstill. In part because ex-students wrote so much about themselves, in part because they often went on to important positions in the academy, journalism, and politics, and in part because the working class would be transformed beyond recognition by the economic crisis of the 1970s, the student half of the story looms more prominently in memories and analyses of 1968. But it was the extension of the movement to the working class that catapulted the country into a potentially regime-threatening political crisis.

As the 1968 generation grew up, France's socioeconomic system had finally moved out from under the shadow of its numerically large and culturally important agricultural sector, and its industrial sector had not yet gone into crisis, either economically or institu-

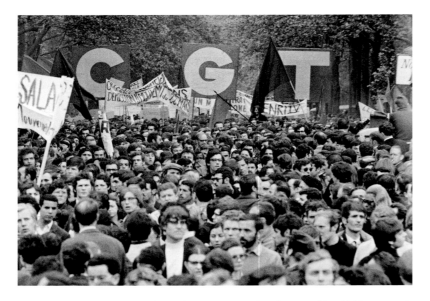

cat. 19. Demonstration with workers carrying CGT banner (Confédération générale du travail, or General Confederation of Labor), May 13, 1968.

tionally. Workers were institutionally present in the public arena through the PCF and the trade unions. The PCF, in these years universally referred to as simply "the Party" because of its organizational strength and high visibility, was in many ways a world unto itself. Stalinist, subservient to Moscow, sectarian, fiercely *ouvriériste* (insistent on its class identity and the political virtues that supposedly resulted), the Party served as both a counter-community and—until May 1968—a protest valve.[65] Throughout the Fourth Republic (1946–1958), it polled about a quarter of the vote. Despite the conservative backlash in June 1968, PCF candidates still garnered a fifth of the vote in the elections that followed the May events. Over the years, a long line of distinguished French intellectuals associated themselves with the PCF, though most eventually left or were thrown out. The Party dominated the most powerful trade union confederation, the Confédération générale du travail (CGT; cat. 19). It governed many municipalities—including Nanterre—in the so-called red belt of working-class suburbs around Paris. It protected its turf against reformist rivals, thus significantly contributing to the persistent organizational and political weak-

ness of France's social democratic tradition, but it had no discernible revolutionary designs against the state.

Landmark advances in working-class rights had been either brokered by France's historically interventionist state in the wake of working-class mobilization or initiated by the state in the context of broader politico-economic goals. In 1936, working-class frustration had prompted a wave of wildcat strikes and factory occupations. The Popular Front government responded by mediating the Matignon Accords: workers secured wage increases, the forty-hour week, some protection for union organizers, and, most importantly, one week of paid vacation. Following the Liberation, the extension of social security and health insurance programs was part of a more general program—supported for different reasons by political actors located across the political spectrum—aimed at promoting economic modernization and growth.

In 1968 the Party was singularly ill-equipped to represent the aspirations of a student generation that felt smothered and infantilized. "Spontaneity" was not a quality that the PCF valued, and its censorious attitudes toward sex mirrored those of its working-class audience. During the initial days of unrest, communist leaders denounced Cohn-Bendit and his comrades as "adventurers," "sons of the upper class" objectively allied with a reactionary government and monopoly capital, "false revolutionaries" who needed to be demasked and isolated lest they compromise the true interests of workers and students.[66] Cohn-Bendit, never favorably disposed toward the PCF, responded by publicly attacking Louis Aragon (1897–1982), a communist poet and iconic figure (cat. 2).

As the student movement gained momentum and spilled across class lines, the PCF and the CGT struggled to steer the protests onto the familiar territory of material demands and political competition, where they would enjoy an advantage over their young rivals. This effort coincided with the interests of the government, which was understandably intent on restoring order. It also whetted the ambitions of the non-communist parliamentary left, whose ongoing and profound disarray had for years left sympathizers without an attractive mainstream political option.

On May 25 the government called union and management representatives to the negotiating table. The Grenelle Accords (the Ministry of Labor is located in the rue de Grenelle) promised workers a 35 percent increase in the minimum wage and significant increases in regular wages. On May 27 striking workers at the Renault factory in Billancourt—the citadel of the French working class—refused the terms of the accords and voted to remain on strike. The rejection suggested coming changes in the trade union world, but in the short term the PCF and CGT were able to impose their solution. The stabilizing effect was critical to the government's survival.

While the PCF scrambled to get back in front of its troops, the government tried to regain the initiative and reverse a dynamic that seemed to be generating increased public support for striking students and workers. Both the prime minister and the president had been out of the country during the first phase of unrest: Pompidou was in Iran and Afghanistan from May 2 to May 11, and de Gaulle was in Romania from May 14 to May 19. On May 24 a nationally broadcast speech by de Gaulle—"all signs . . . point to the necessity of social change and everything suggests that this mutation must include the possibility of greater participation for everyone in the functioning and the results of activities in which they have a stake"[67]—failed to produce its intended effect.

On May 29, de Gaulle vanished. He was consulting General Jacques Massu in Baden-Baden, but at the time even his prime minister did not know where he had gone. Within the political class, the tension was palpable. The Fifth Republic appeared on the brink of oblivion. On May 24 demonstrating students had shouted "La Ve au clou, la VIe c'est nous!"[68] Somewhat more realistically, on May 28 François Mitterrand announced his availability should the presidency become vacant, and on May 29 Pierre Mendès France conceded that he would not refuse governmental responsibilities should the left accede to power.[69]

During the many years in which he had towered over the French political scene, Charles de Gaulle had both saved and subverted French democracy—not sequentially, as wartime admirers and postwar critics like Mendès France tended to believe, but simultaneously. Never one to hang on to power for its own sake, de Gaulle had resigned as head of government in 1946 and bitterly criticized the emerging institutions of the Fourth Republic. He contended that the reestablishment of a parliamentary republic in a country where public opinion was fragmented and polarized would lead to instability, paralysis, and national decline. His constitutional alternative, a mixed presidential-parliamentary system, was rejected by the political class. The short political history of the Fourth Republic appeared to confirm de Gaulle's predictions. By 1958 the army seemed poised to break with its tradition of staying out of politics. Presidentialism looked better than paratroopers, so de Gaulle was summoned out of self-imposed retirement and allowed to write his own constitutional ticket. The plebiscitary institutions he devised strengthened and personalized executive authority. They preserved the principle of democratic accountability (through regular and free elections), but they hobbled representation: they disadvantaged the political left (by leaving the socialists an unattractive choice between political isolation and cooperation with the communists) and drastically reduced the powers of parliament.

De Gaulle did not create the fragmentation or polarization that had made democratic authority so hard to institutionalize in France: their sources lay buried in the past. But if organizing effective representative mechanisms was an impossible task, insulating the executive was not a sustainable solution. From the beginning, Mendès France had predicted disaster, and on May 19 de Gaulle's most intransigent and principled constitutional critic said, in essence, "I told you so":

By constantly, and for ten years, refusing to talk either with worker, student, and peasant representatives or with elected officials, by maintaining (and with such contempt for public opinion!) a monopoly over all decisions, the government has created a revolutionary situation. Now it can neither use force without unleashing a tragic chain of events nor initiate a useful dialogue with the masses, which have risen against its policies.

It can render only one service to the country: it can resign.[70]

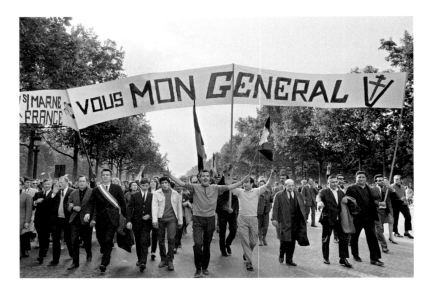

cat. 29. Pro-Gaullist demonstration, May 30, 1968.

De Gaulle believed that national unity and national greatness were two sides of the same coin, and that the preservation of the one and the pursuit of the other depended on an executive simultaneously strong enough to define an independent path in a competitive international system and legitimate enough to be the voice of France in the world. A nation mesmerized by its international prestige would, de Gaulle believed, be less inclined to dwell on its domestic divisions.

He was wrong. De Gaulle's emphasis on authority and self-denial put him on a collision course with the students and workers who would revolt in 1968—a collision in no way cushioned by the fact that the General did not need instruction from the youthful activists of the Comité Vietnam national in order to articulate a fundamental critique of American policy in Indochina any more than he needed Maoists to suggest that it might be in France's geostrategic interest to recognize the People's Republic of China.[71] De Gaulle ended the May crisis with another act of authority, not a move toward greater representation. It was a Band-Aid, not a cure—and it announced future crises.

On May 30, de Gaulle returned to Paris and at 4:30 p.m. again spoke to the nation; this time, he connected. An hour and a half after his speech, a massive pro-government rally gathered on the Champs-Elysées (cat. 29). The General's first speech (on May 24) had laid out an intelligent analysis of the situation and a tentative solution; the second speech, punctuated by repeated use of the first person singular to remind listeners of who was in charge and of the indefinite pronoun ("on") to evoke an immediate and dire threat, was worthless as an analysis but politically potent as a response. The General announced legislative elections, "unless one intends to gag the whole French people, by preventing it from expressing itself while at the same time preventing it from normal living, using the same means being used to prevent students from studying, teachers from teaching, workers from working. These means include the intimidation, intoxication, and tyranny exercised by groups remotely controlled by a party which is a totalitarian enterprise, even if it already has rivals in this respect."[72]

De Gaulle's second speech was effective in part because of the tone he struck, but also because people were tiring of the disorder and frightened by the sharpening violence—of which de Gaulle's polarizing language suggested there might be more. Public transport was paralyzed; bread and other supplies were running short; uncertainty was beginning to seem less of a stimulant and more of a threat. On June 10, a seventeen-year-old Maoist drowned while fleeing police. The next day, riot police shot a worker dead; another worker died in a fall. Rumors were rife that the right was organizing paramilitary bands with the connivance of the government. Recess was over.

* * *

In many ways, the causes, mood, and purposes of the 1968 movement seem a world removed from the student-initiated protests that intensified into a political crisis in the spring of 2006. The events of 1968 were the product of prosperity, and its youthful protagonists used the twentieth century's great competing ideologies as foils. The purportedly revolutionary aspirations of the protesters focused on relationships rather than material rewards; the demands they formulated were romantic, naive, sassy, and predi-

cated on a sense of expanding possibilities. In contrast, the 2006 movement fed on the social frustration created by decades of persistently high unemployment; its mood was pessimistic, defensive, and angry. The events of 1968 swept the country unannounced by precursor events (except in other countries). In contrast, the social explosion provoked by the forced passage of Prime Minister Dominique de Villepin's *contrat première embauche*, a measure aimed at facilitating the creation of jobs for young people by making it easier for employers to fire new hires if they were under age twenty-six, capped a year already punctuated by two major crises: the failed referendum of May 2005 on a proposed constitution for the European Union, and the urban riots of November 2005. During the latter, the government had declared a state of emergency.

Despite these and other differences, analytical connections do link the events of May 1968 to the unrest of 2006. One connecting line would follow the complicated story of educational reform. The school system has changed beyond recognition since the 1960s, but France is still paying the price for the incoherent and incomplete educational reforms adopted in the 1950s and 1960s. Questions related to the school system's structure, not to mention its performance (social, economic, and political as well as intellectual), remain contentious. With nearly all children remaining in school through adolescence, teachers must accommodate a highly heterogeneous public, rendering reconsideration of both programs and pedagogy urgent. At the same time, schools now confront, within their walls, the problems and injustices that society has been unable to solve beyond those walls.

These difficulties were not created by the alleged permissiveness sometimes imputed to teachers and parents shaped by 1968. Nor does anyone seriously propose rolling back the massification of the school system. No system would have been problem-free, as the experiences of comparable countries (France, Britain, Germany, the United States) demonstrate, nor can any school system singlehandedly solve problems of social exclusion or unemployment. But the French system as currently organized is set up to produce failure, especially among socially less advantaged children.

May 1968 accelerated reforms at every level, but the basic issues went unaddressed, while school reform remained the third rail of French politics. The abortive projects of Alain Savary in 1984, Alain Devaquet in 1986, Edouard Balladur in 1995, and Claude Allègre in 2000, as well as lesser crises and the prolonged controversy regarding Muslim headscarves, are all reminders of how explosive issues touching the school system can be.

A related line connecting May 1968 to 2006 is even more significant, and it concerns the unresolved problem of representation. For a brief moment in the late 1970s and early 1980s two competitive electoral blocs appeared to be emerging. That trend was undone by the collapse of the communist party and the subsequent deinstitutionalization of what had been the working class—making way, most notably, for the rise of the extreme right National Front and paving the way for the eruption of urban violence in 2005.[73] Since 1992 the titles of the electoral studies published by the Fondation nationale des sciences politiques have pointed to a persistent crisis of representation: thus the volume on the disastrous presidential election of 2002 appeared under the title *Le vote de tous les refus*.[74]

In 2004, Henri Mendras, throughout a long academic career one of the most assiduous observers of social trends in France, looked back over the postwar decades and saw a brighter picture: "This country that seemed completely to have lost its nerve, suddenly saw an extraordinary renaissance."[75] France, Mendras and his co-author asserted, had learned to change—without the assistance of a revolution.[76] The 1968 generation's aptitude for informal self-government, combined with the dissolution of the classic social classes, had obviated the need for strong institutions.[77]

With the disappearance of major ideological conflict, one could think that society has become amorphous. Indeed, it has ceased to be organized by massive archictectural structures, by sharply distinguished social groups. Instead, it has become more complex, organized by more discrete, diverse, and overlapping structures that leave individuals a wider sphere of freedom.

Local institutions have become stronger; the higher standard of living, the reduction of working hours have permitted the birth of a civilization based on leisure, an explosion of cultural activity, and the reinforcement of social interaction based on choice and facilitated by technological innovations. Most people today are at ease in this new social fabric in which each person invents his or her own way of life. A minority of less privileged individuals, deprived of signposts, is disoriented, but this gap does not cause significant social antagonism.[78]

Mendras's account is not wrong, but it rings strangely in the wake of the riots of November 2005 and the strikes (and accompanying violence) of 2006. In 1968 actors on all sides, including those at the highest levels, were conscious of the dangers that a particular institutional pattern—strong on authority and weak on representation—had engendered. In 2006, Villepin gave no indication of understanding the complex leadership problems he faced—and that his own actions compounded.[79] At the same time, the alarm suggested by the titles of the electoral studies fails to capture the higher living standards and richer range of choices to which Mendras makes reference.

May 1968 was simultaneously a product of, and a relay station for, the institutional and representational crisis that lay behind the alienation and violence of 2005–6. But it was also, and again simultaneously, a sign and a cause of a social world in which, as the 1968 slogan had demanded, fewer things are forbidden, whether for normative or for material reasons. As we all continue to puzzle over the sources and legacies of May 1968, people in search of France (and of renewed democratic mechanisms for a changed world) should keep both realities in view.

NOTES

Abbreviations appearing in the text

CGT: Confédération générale du travail (General Confederation of Labor)
FEN: Fédération de l'éducation nationale (National Education Federation)
JEC: Jeunesse étudiante chrétienne (Christian Student Youth)
JCR: Jeunesse communiste révolutionnaire (Revolutionary Communist Youth)
LCR: Ligue communiste révolutionnaire (Revolutionary Communist League)
PCF: Parti communiste français (French Communist Party)
PSU: Parti socialiste unifié (Unified Socialist Party)
SDS: Sozialistischer Deutscher Studentenbund (Association of German Socialist Students)
SNES: Syndicat national de l'enseignement secondaire (National Union of Secondary School Educators)
SNE-Sup: Syndicat national de l'enseignement supérieur (National Union of University Educators)
SNI: Syndicat national des instituteurs (National Union of Teachers)
UEC: Union des étudiants communistes (Union of Communist Students)
UJC-ml: Union des jeunesses communistes—marxiste-léniniste (Young Communist Union—Marxist-Leninist)
UNEF: Union nationale des étudiants de France (National Union of Students)

1. Exchange recounted in Pierre Grappin, *L'Ile aux peupliers: De la Résistance à mai 68: Souvenirs du doyen de Nanterre* (Nancy: Presses Universitaires de Nancy, 1993), p. 267.

2. Régis Debray, *Loués soient nos seigneurs: Une éducation politique* (Paris: Gallimard, 1996), p. 27. Léon Blum (1872–1950) led the socialist party during the interwar years and served as prime minister after the Popular Front victory in 1936 and again briefly in 1946–47. After the defeat of 1940, he was tried by the Vichy government and deported by the Germans. André Malraux (1901–1976), antifascist intellectual, novelist, *résistant*, and art critic, served as de Gaulle's minister of culture from 1958 to 1969. Georges Bernanos (1888–1948), Catholic, monarchist, journalist and novelist, blistering critic of Franco, and partisan of de Gaulle's Free French during World War II, was particularly influential in Catholic circles.

42

3. Hervé Hamon and Patrick Rotman, *Génération*, vol. 1, *Les années de rêve* (Paris: Le Seuil, 1987), p. 524. The remark is not reproduced in *Le Monde*'s account of the evening ("M. Jean-Paul Sartre à la Sorbonne: pour l'association du socialisme et de la liberté," May 22, 1968, p. 3), and it appears in slightly different form in different sources; see Laurent Joffrin, *Mai 68: Histoire des Evénements* (Paris: Le Seuil, 1988), p. 203.

4. The changes have been particularly spectacular in what can loosely be defined as "family life." See Louis Dirn, *La société française en tendances, 1975–1995* (Paris: Presses universitaires de France, 1998); Olivier Galland and Yannick Lemel, eds., *La nouvelle société française: Trente années de mutation* (Paris: Armand Colin, 1998); Henri Mendras and Laurence Duboys Fresnay, *Français, comme vous avez changé: Histoire des Français depuis 1945* (Paris: Tallandier, 2004).

5. Grappin, *L'Ile aux peupliers*, p. 266.

6. Michel Foucault (1926–1984) emphasized the disciplinary aspects of modern social institutions; see, for example, *Surveiller et punir: Naissance de la prison* (Paris: Gallimard, 1975). For a suggestive analysis of the secular decline of the "institutional program," see François Dubet, *Le Déclin de l'institution* (Paris: Le Seuil, 2002).

7. Students of French politics will recognize the allusion to Stanley Hoffmann et al.'s seminal study *In Search of France* (Cambridge, Mass.: Harvard University Press, 1963).

8. See, for example, the much-cited argument of Luc Ferry and Alain Renaut in *La pensée 68: Essai sur l'antihumanisme contemporain* (Paris: Gallimard, 1988).

9. Herbert Marcuse, *One Dimensional Man: Studies in the Ideology of Advanced Industrial Society* (Boston: Beacon Press, 1964).

10. Pierre Viansson-Ponté conducted the interview with Marcuse; *Le Monde des Livres*, May 11, 1968, pp. I and III.

11. For France, the best printed collection of primary source documents remains the large volume edited by Alain Schnapp and Pierre Vidal-Naquet, *Journal de la Commune étudiante: Textes et documents, novembre 1967–juin 1968* (Paris: Le Seuil, 1969). As its title indicates, it focuses on the student movement. There is no equivalent volume for the workers' strikes; see, however, René Mouriaux et al., eds., *1968: Exploration du mai français*, vol. 1, *Terrains* (Paris: L'Harmattan, 1992).

12. See Antoine Prost, *Education, société et politiques: Une histoire de l'enseignement de 1945 à nos jours*, rev. ed. (Paris: Le Seuil, 1997), p. 69.

13. Pierre Viansson-Ponté, "Quand la France s'ennuie," *Le Monde*, March 15, 1968, pp. 1 and 9.

14. So began the introduction to a series of articles entitled "Les étudiants entre l'apathie et la violence," *Le Monde*, May 7, 1968, p. 1.

15. Benno Ohnesorg was shot by a plainclothes officer during a June 2 demonstration in West Berlin against the visit of the Shah of Iran.

16. In its edition of May 15, 1968, p. 2, *Le Monde* ran articles on unfolding events under the title "La nuit des barricades au quartier Latin." *Le Monde* did not appear on May 14.

17. Roche was motivated in part by worries that rightwing students were planning an attack on the protesters. The protesting students were also expecting a raid by rightwing adversaries. See Hamon and Rotman, *Les années de rêve*, pp. 447–452.

18. See Joffrin, *Mai 68*, p. 226. During the course of the month, important elements among the protesters flirted with the possibility of escalation; see, for example, Hamon and Rotman, *Les années de rêve*, pp. 543–548.

19. Grimaud's predecessor, Maurice Papon, would almost certainly not have had the same scruples, and as was the case with the students, there were ranking officials within the government who were more willing than others to take risks.

20. Most of the dead were Algerians. The police violence was occasioned by a peaceful rally in favor of Algerian independence. See Jean-Luc Einaudi, *Octobre 1961: Un massacre à Paris* (Paris: Fayard, 2001).

21. De Gaulle survived an attempted military coup in April 1961 and assassination attempts in September 1961 and August 1962.

22. By all accounts, the move was considered but rejected, by some in order to avoid the risk of escalation, by others out of fear that conscripts would side with the demonstrators. For contemporaneous commentary and speculation, written at a particularly tense and uncertain moment in the crisis, see "L'Armée paraît déterminée à obéir à tout gouvernement pourvu qu'il soit légal," *Le Monde*, May 31, 1968, p. 5.

23. Joffrin, *Mai 68*, p. 227.

24. Philippe Alexandre, *L'Elysée en péril, 2/30 mai 1968* (Paris: Fayard, 1968), p. 91, cited in Jean-Pierre Le Goff, *Mai 68, l'héritage impossible* (Paris: La Découverte, 1998, 2002), p. 117. On the afternoon of May 26, however, Pompidou released a statement warning that the police had been ordered to use all necessary means to disperse unauthorized assemblies; many people, including Mendès France, feared that the government might resort to lethal force. Six prominent academics, including two Nobel laureates and Claude Lévi-Strauss, warned the government that the "destruction physique ou morale du mouvement étudiant serait la ruine d'un espoir qui est celui du pays"; see "'Le premier ministre paraît menacer le mouvement étudiant d'une liquidation brutale,'" *Le Monde*, May 28, 1968, p. 8.

25. Joffrin, *Mai 68*, p. 209.

26. See Guy Brucy, *Histoire de la FEN* (Paris: Belin, 2003), p. 319.

27. De Gaulle cut short a state visit to Romania and arrived in Paris late in the evening of Saturday, May 18. He made the remark on May 19, in the presence of the prime minister, the minister of the interior (Christian Fouchet), the minister of information (Pierre Gorse), and the prefect of police (Maurice Grimaud).

Le Monde reported the story in its edition of May 21 (p. 3), accompanying the news story by another, culturally indicative one, comparing de Gaulle's use of the term *chienlit* to that of the sixteenth-century Renaissance writer François Rabelais. De Gaulle's words can be translated roughly as "Reform, yes; a stinking mess, no." The student reply was "the stinking mess, he's it."

28. Aron recounts this exchange in his memoirs, in a passage devoted to May 1968; see Raymond Aron, *Mémoires: 50 ans de réflexion politique* (Paris: Julliard, 1983), p. 493. Aron's immediate analysis of the events appeared as *La Révolution introuvable* (Paris: Fayard, 1968).

29. See, for example, Gordon Wright, *Rural Revolution in France: The Peasantry in the Twentieth Century* (Stanford: Stanford University Press, 1964); Henri Mendras, *La Seconde Révolution française, 1965–1984*, rev. ed. (Paris: Gallimard, 1994).

30. Antoine Prost, *Histoire de l'enseignement en France, 1860–1967* (Paris: Armand Colin, 1968), p. 436.

31. Joffrin, *Mai 68*, p. 151.

32. Unemployment statistics are easily available from the United States Department of Labor, Bureau of Labor Statistics, Foreign Labor Statistics, at http://www.bls.gov/fls/home.htm.

33. For figures, see Antoine Prost, *Histoire générale de l'enseignement et de l'éducation en France*, vol. 4, *L'école et la famille dans une société en mutation (1930–1980)* (Paris: Nouvelle Librairie de France, 1981), p. 265. Due to the structural complexity of the French educational system (see below) and to structural change over time, accurate time series figures are impossible to compile, and figures cited in different sources do not concord. All figures given here should be taken to indicate orders of magnitude. On the statistical problems, see Antoine Prost, *L'enseignement s'est-il démocratisé? Les élèves des lycées et collèges de l'agglomération d'Orléans de 1945 à 1980* (Paris: Presses universitaires de France, 1986), pp. 27–43.

34. Prost, *Histoire générale*, p. 273.

35. Figure cited by Rector Jean Roche in his May 3 statement suspending classes at the Sorbonne; see "La Liberté des examens sera assurée affirme le recteur," *Le Monde*, May 5–6, 1968, p. 9.

36. See Prost, *Histoire générale*, pp. 260ff. See also Jean-Charles Asselain, *Le Budget de l'Education nationale (1952–1967)* (Paris: Presses universitaires de France, 1969).

37. Prost, *Histoire générale*, pp. 275ff.

38. For statistics, see Brucy, *Histoire de la FEN*, p. 261.

39. Prost, *Histoire générale*, pp. 276ff.

40. On the UNEF, see Didier Fischer, *L'histoire des étudiants en France, de 1945 à nos jours* (Paris: Flammarion, 2000), and Alain Montblachon, *Histoire de l'UNEF de 1956 à 1968* (Paris: PUF, 1983).

41. On Mendès France, see Jean Lacouture, *Pierre Mendès France* (Paris: Le Seuil, 1981).

42. For membership estimate, see Montblachon, *Histoire de l'UNEF*, p. 106. For the unionization rate among workers, see graph in Louis Dirn, *La société française en tendances, 1975–1995* (Paris: Presses universitaires de France, 1998), p. 276.

43. Estimation in Montblachon, *Histoire de l'UNEF*, p. 188. *Le Monde* estimated UNEF's membership in 1968 at 45,000 to 50,000, as against more than 100,000 in 1961 (Frédéric Gaussen and Guy Herzlich, "Les étudiants entre l'apathie et la violence," part III, "Des organisations déchirées," *Le Monde*, May 9, 1968, p. 6).

44. See, for example, *Le Monde*, May 7, 1968, p. 10, boxed paragraphs.

45. See Hamon and Rotman, *Les années de rêve*, p. 448.

46. Now director of the School of Fine Arts in the Breton city of Rennes, Sauvageot may be the only prominent actor in the May drama who has not offered any retrospective public reflections on the events or his role in them.

47. Their philosophically more coherent and interesting cousins were ex-Trotskyites associated with the group Socialisme ou barbarie. The latter group, organized in the late 1940s and deeply interested in devising revolutionary alternatives to totalitarianism and technocracy, included some of postwar France's best minds, among them Cornelius Castoriadis (an economist, 1922–1997), Claude Lefort (a philosopher, b. 1924), and Edgar Morin (a sociologist, b. 1921). All three were sympathetic to, and acute observers of, the May 1968 movement; see Cornelius Castoriadis, Claude Lefort, and Edgar Morin, *Mai 68: La brèche, suivi de Vingt ans après* (Brussels: Editions Complexe, 1988).

48. For a short excerpt from the 1966 pamphlet, see Alain Schnapp and Pierre Vidal-Naquet, eds., *Journal de la Commune étudiante: Textes et documents, novembre 1967–juin 1968* (Paris: Le Seuil, 1969), pp. 69–71.

49. For an account of these groups, see Frédéric Charpier, *Génération Occident: De l'extrême droite à la droite* (Paris: Le Seuil, 2005).

50. Figure cited in Le Goff, *Mai 68, l'héritage impossible*, p. 49.

51. See Charpier, *Génération Occident*, p. 170n2.

52. See *Le Monde*, May 9, 1968, p. 7, and May 8, 1968, p. 8. The Gaullist Union pour la Nouvelle République was the governing party. Rector Roche had impugned the influence of a "small group of students" and the recently appointed minister of education, Alain Peyrefitte, had spoken of a "handful of troublemakers"; see "Un manque de sang-froid," *Le Monde*, May 5–6, 1968, p. 1.

53. Figures in Montblachon, *Histoire de l'UNEF*, p. 186.

54. Grappin, *L'Ile aux peupliers*, p. 252.

55. This famous episode is recounted in Hamon and Rotman, *Les années de rêve*, pp. 400–402. The minister in question was François Missoffe. For Missoffe's response to the May events, see "M. Missoffe: La contestation des jeunes est un appel," *Le Monde*, May 23, 1968, p. 11.

56. See account in Hamon and Rotman, *Les années de rêve*, pp. 528, 556ff. *Le Monde* followed Cohn-Bendit's movements, and responses to the government's efforts to keep him out of the country, as closely as it could. On Cohn-Bendit's return, see "Le leader du mouvement du 22 mars a reçu les journalistes à minuit à la Sorbonne," *Le Monde*, May 30, 1968, p. 8.

57. For Cohn-Bendit's own assessment of the events in which he played so central a role, see Cohn-Bendit, *Le grand bazar* (Paris: Belfond, 1975) and *Nous l'avons tant aimée, la révolution* (Paris: Bernard Barrault, 1986), and a conversation with Bernard Kouchner facilitated by a third veteran of 1968, Michel-Antoine Burnier, *Quand tu seras président . . .* (Paris: Laffont, 2004).

58. On the FEN, see Brucy, *Histoire de la FEN*, René Mouriaux, *Le syndicalisme enseignant en France* (Paris: PUF [Que sais-je], 1996); Véronique Aubert et al., *La forteresse enseignante: La Fédération de l'Éducation Nationale* (Paris: Fayard, 1985).

59. Prost, *Histoire générale*, p. 280.

60. Brucy, *Histoire de la FEN*, p. 312.

61. See *Le Monde*, May 4, 1968, p. 10.

62. See account in Maurice Grimaud, *En mai, fais ce qu'il te plaît* (Paris: Stock, 1977), passim.

63. See "Hésitations au congrès du Syndicat national de l'enseignement supérieur," *Le Monde*, May 26–27, 1968, p. 5, and "M. Geismar abandonne la direction du Syndicat national de l'enseignement supérieur," *Le Monde*, May 28, 1968, p. 8.

64. Grappin, *L'Ile aux peupliers*, p. 248.

65. See Georges Lavau, "Le Parti communiste dans le système politique français," in Frédéric Bon et al., *Le communisme en France* (Paris: Armand Colin/Fondation nationale des sciences politiques, 1969), pp. 7–81; Georges Lavau, *A quoi sert le Parti communiste français* (Paris: Fayard, 1981).

66. Georges Marchais in *L'Humanité*, May 3, 1968; see account in "Le parti communiste ne sous-estime plus la 'malfaisante besogne' des 'pro-chinois,'" *Le Monde*, May 4, 1968, p. 10.

67. Charles de Gaulle, May 24, 1968, text of speech in Charles de Gaulle, *Discours et messages*, vol. 5, *Vers le terme, janvier 1966–avril 1969* (Paris: Plon, 1970), pp. 316ff.

68. "The Fifth Republic in the pawnshop, the Sixth Republic is us!" See Hamon and Rotman, *Les années de rêve*, p. 538.

69. Without prior consultation, Mitterrand had suggested Mendès France as the likely head of a transitional government. The two men had diametrically opposed temperaments; they also advocated different political strategies. On Mendès France's perceptions of and role in the events of May 1968 and their aftermath, see Pierre Mendès France, *Oeuvres complètes*, vol. 5, *Préparer l'avenir, 1963–1973* (Paris: Gallimard, 1989), pp. 342ff and passim, and Jean Lacouture, *Pierre Mendès France* (Paris: Le Seuil, 1981), pp. 472–494.

70. Statement released on May 19, 1968, reproduced in Mendès France, *Préparer l'avenir*, pp. 344ff.

71. For de Gaulle's critique of American policy in Indochina, see in particular his September 1, 1966, speech in Phnom Penh, text in Charles de Gaulle, *Vers le terme, janvier 1966–avril 1969*, pp. 80–84. France extended diplomatic recognition to the PRC in January 1964.

72. Charles de Gaulle, May 30, 1968, text of speech in de Gaulle, *Vers le terme, janvier 1966–avril 1969*, pp. 319ff. The reference to a totalitarian party is of course an attack on the PCF; its totalitarian rivals were the *groupuscules*.

73. See esp. Stéphane Beaud and Michel Pialoux, *Violences urbaines, violence sociale: Genèse des nouvelles classes dangereuses* (Paris: Fayard, 2003).

74. Other titles include Philippe Habert, Pascal Perrineau, and Colette Ysmal, eds., *Le vote éclaté: Les élections régionales et cantonales des 22 et 29 mars 1992* (Paris: Département d'études politiques du Figaro and Presses de la Fondation nationale des sciences politiques, 1992); Philippe Habert, Pascal Perrineau, and Colette Ysmal, eds., *Le vote sanction: Les élections législatives des 21 et 28 mars 1993* (Paris: Département d'études politiques du Figaro and Presses de la Fondation nationale des sciences politiques, 1993); Pascal Perrineau and Colette Ysmal, eds., *Le vote de crise: L'élection présidentielle de 1995* (Paris: Département d'études politiques du Figaro and Presses de Sciences Po, 1995); Pascal Perrineau and Colette Ysmal, eds., *Le vote surprise: Les élections législatives des 25 mai et 1er juin 1997* (Paris: Département d'études politiques du Figaro and Presses de Sciences Po, 1998); Pascal Perrineau and Dominique Reynié, eds., *Le vote incertain: Les élections régionales de 1998* (Paris: Presses de Sciences Po, 1999); Pascal Perrineau and Colette Ysmal, eds., *Le vote de tous les refus: Les élections présidentielle et législatives 2002* (Paris: Presses de Sciences Po, 2003). See also Bruno Cautrès and Nonna Mayer, eds., *Le nouveau désordre électoral: Les leçons du 21 avril 2002* (Paris: Presses de Sciences Po, 2004), Pascal Perrineau, ed., *Le vote européen 2004-2005: De l'élargissement au référendum français* (Paris: Presses de Sciences Po, 2005), and Bernard Dolez, Annie Laurent, and Claude Patriat, eds., *Le vote rebelle: Les élections régionales de mars 2004* (Dijon: Editions universitaires de Dijon, 2005).

75. Mendras and Fresnay, *Français, comme vous avez changé*, p. 17.

76. Ibid., p. 366.

77. Ibid., p. 365; see also pp. 60ff.

78. Ibid., p. 16.

79. The blindness is all the more interesting because in 2002, Villepin had published a book on France's contemporary problems and possibilities whose analysis suggested that its author might either be especially attentive to transmission belts—or neglect them entirely. See Dominique de Villepin, *Le cri de la gargouille* (Paris: Albin Michel, 2002).

Plates

I was not really impartial simply because my sympathy was with the students and their grievances rather than the political establishment. Georges Pompidou, who was Prime Minister in 1968, would at the outset of his later presidential campaign set as a priority: every housewife should have a washing machine. This was his view of the future!

While I was a journalist, I had always worked as a documentary reporter, but at the same time as a photographer seeking to make personal creative work. I was covering the events in 1968 for a left-leaning journal but also trying to make memorable images—not only by recounting the event but also by taking a true photograph, which in a separate context could stand by itself.

These images are real because they are not posed (except for the portraits I did of Daniel Cohn-Bendit). My photographs don't show violence; some of them are even tender. One could say that my photographs can be considered, at one and the same time, both aesthetic and documentary.

It is true that I am interested in those "at the margins" of events: for example, rather than showing the demonstrators burning a car, I would prefer to show the consternation of the spectators (and then there was the danger that the police might recognize the protesters from the photographs).

—Serge Hambourg, July 2006

cat. 1. Serge Hambourg self-portrait taken across the street from the Sorbonne, May 10, 1968. ➤

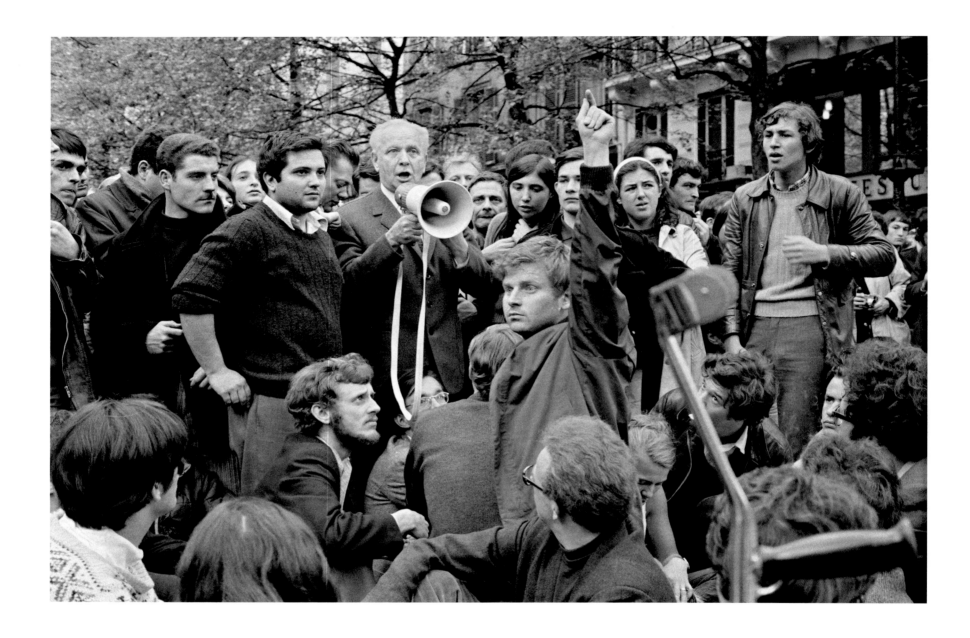

cat. 2. Writer Louis Aragon addressing the crowd through a bullhorn at the Place de la Sorbonne;
student leader Daniel Cohn-Bendit with arm raised, May 9, 1968.

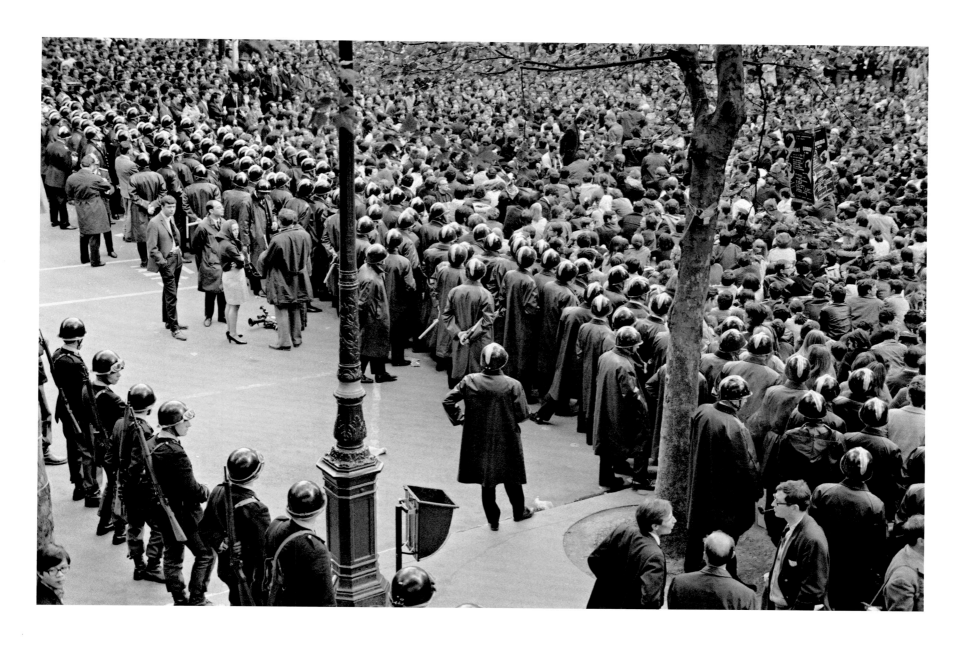

cat. 3. Line of police holding back crowd near the Place de la Sorbonne, May 9, 1968.

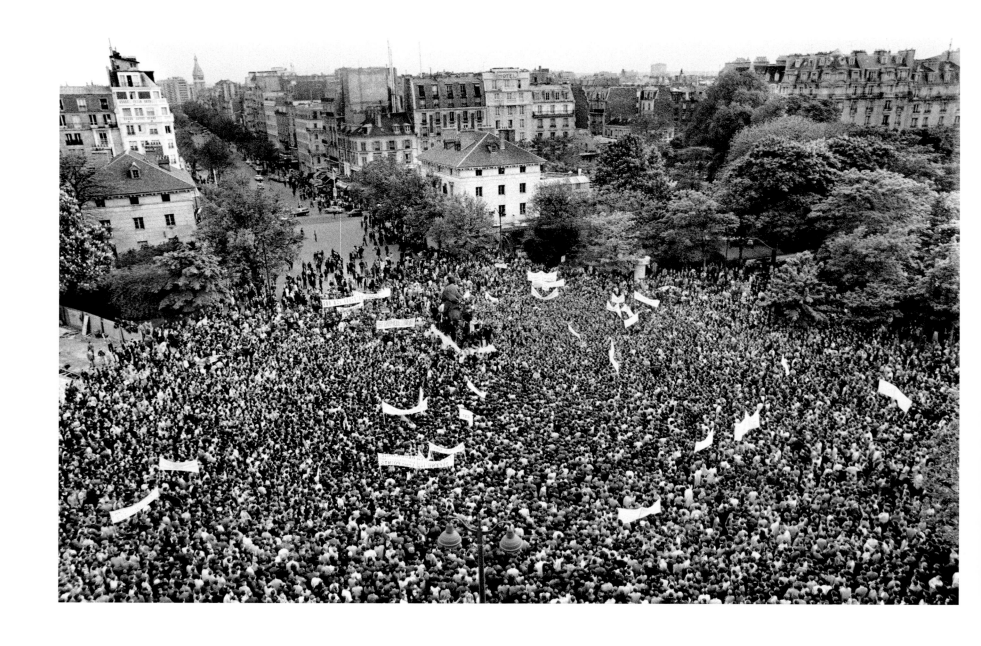

cat. 4. Demonstration at the Place Denfert-Rochereau, May 10, 1968.

52

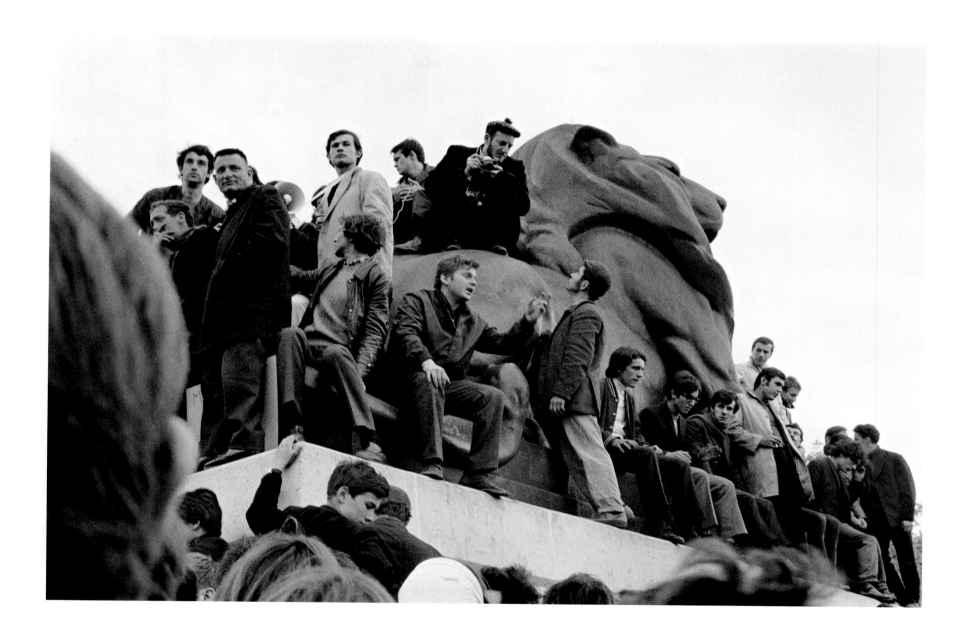

cat. 5. Demonstrators (including Daniel Cohn-Bendit sitting with left hand raised and the activist Elie Kagan with a camera) on *Le Lion de Belfort* (1880) by sculptor Frédéric-Auguste Bartholdi at Place Denfert-Rochereau, May 10, 1968.

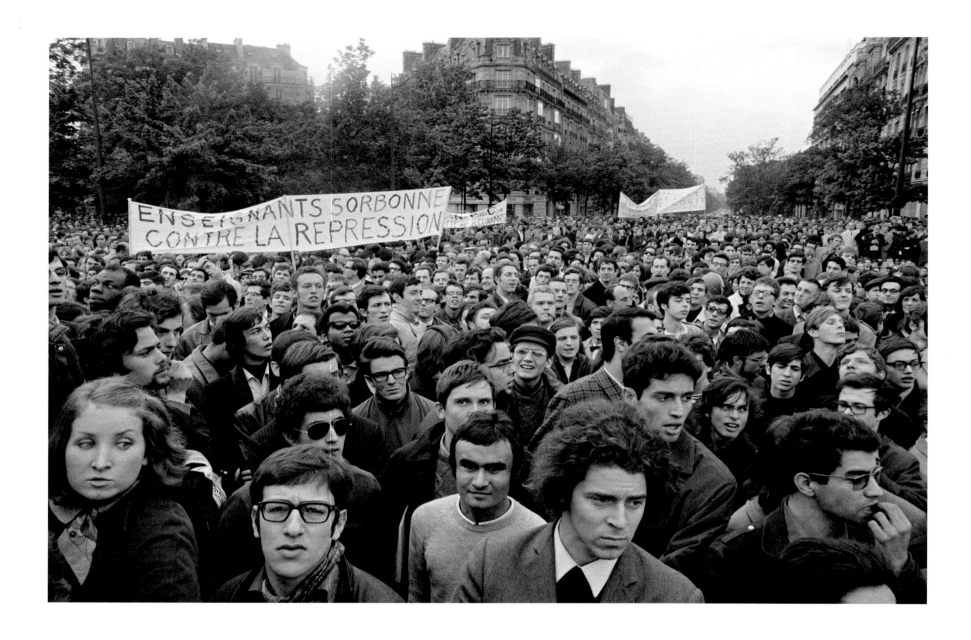

cat. 6. Crowd of marching protestors with sign reading "Sorbonne Teachers against Repression," May 10, 1968.

cat. 7. Demonstrators on the rue Monge, Paris, May 10, 1968. ➤

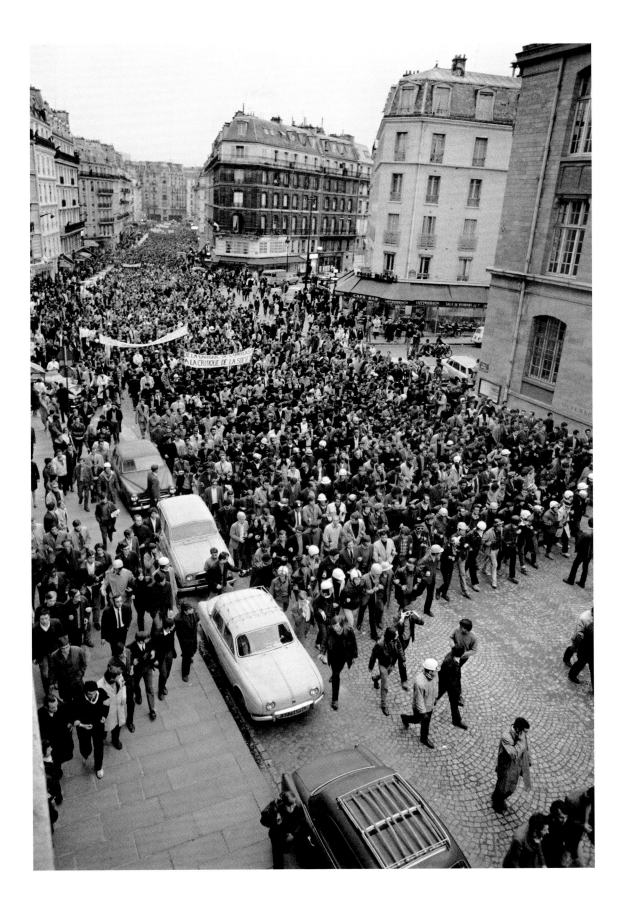

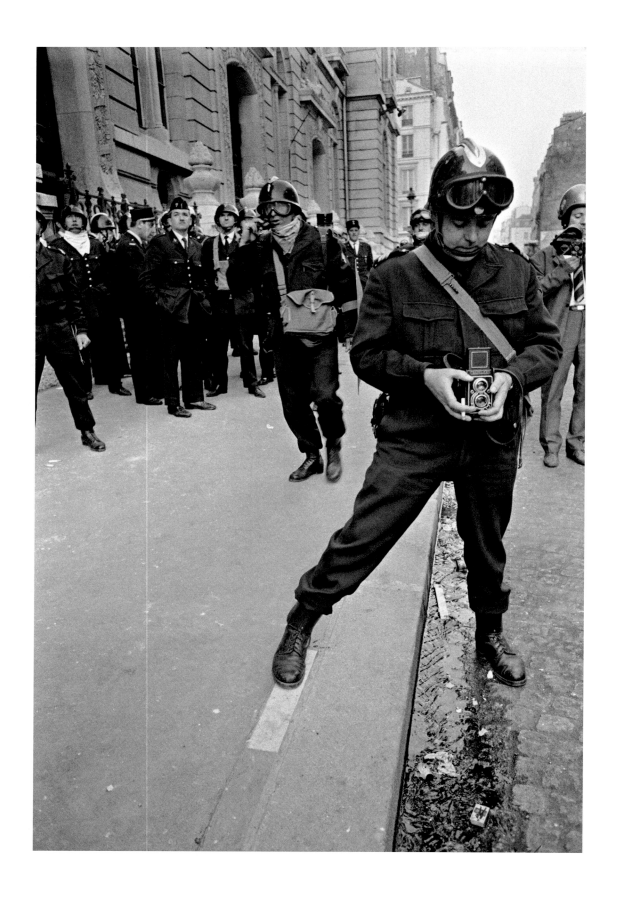

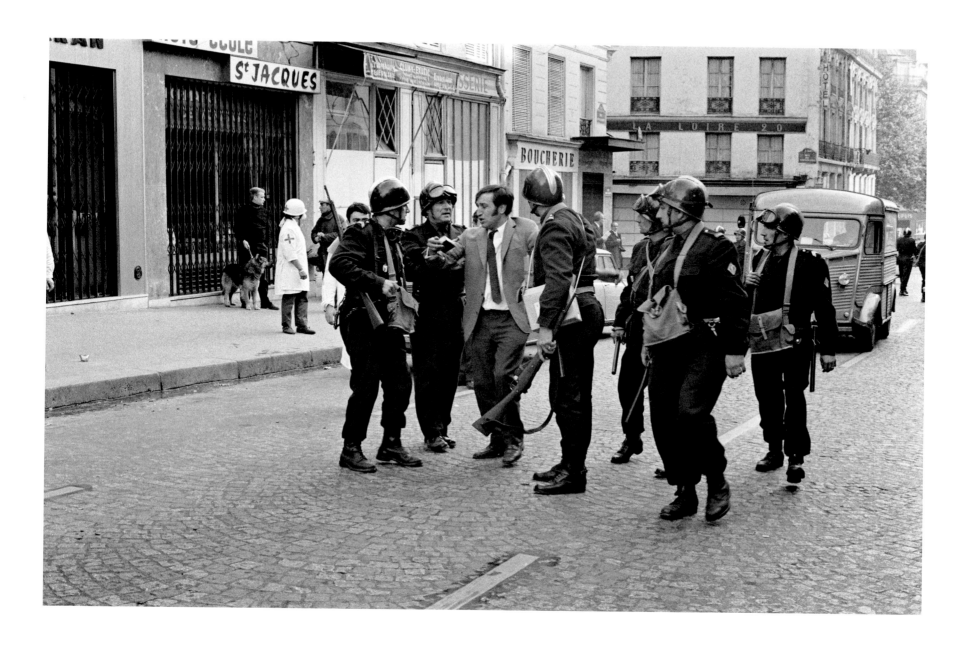

cat. 9. Police surrounding man with first-aid workers behind them, Latin Quarter, May 10, 1968.

◄ cat. 8. Policeman with camera near an entrance to the Sorbonne, Latin Quarter, May 10, 1968.

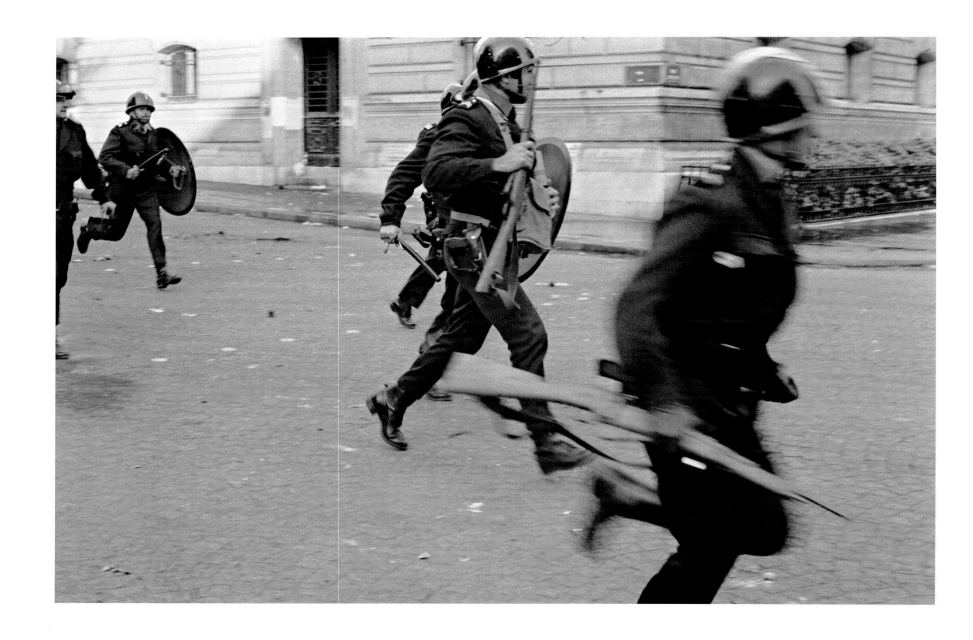

cat. 10. Police running, Latin Quarter, May 10, 1968.

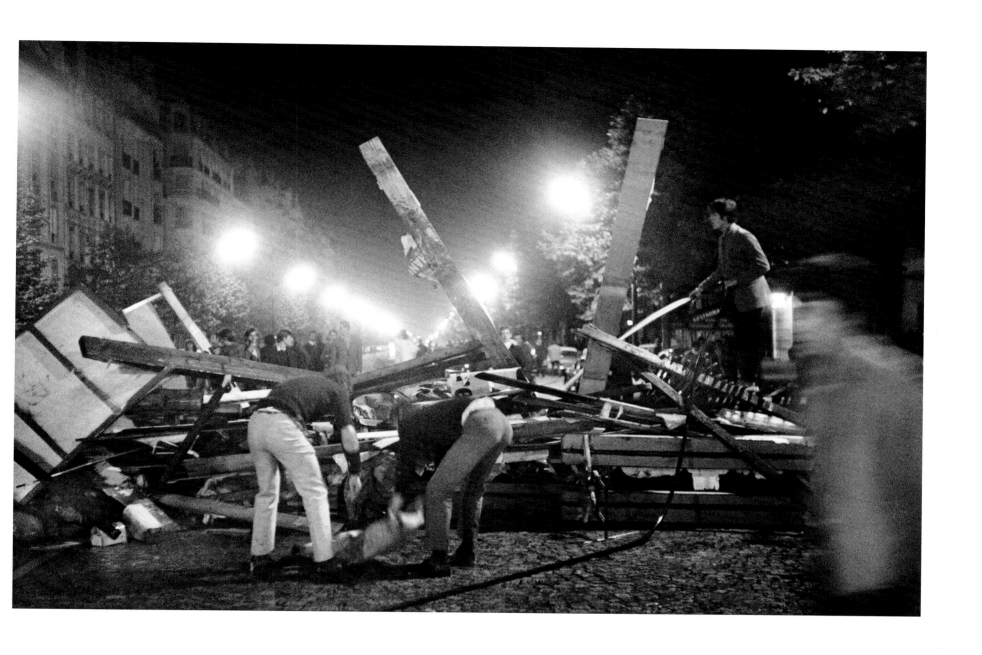

cat. 11. Building barricades at night, Latin Quarter, May 10–11, 1968.

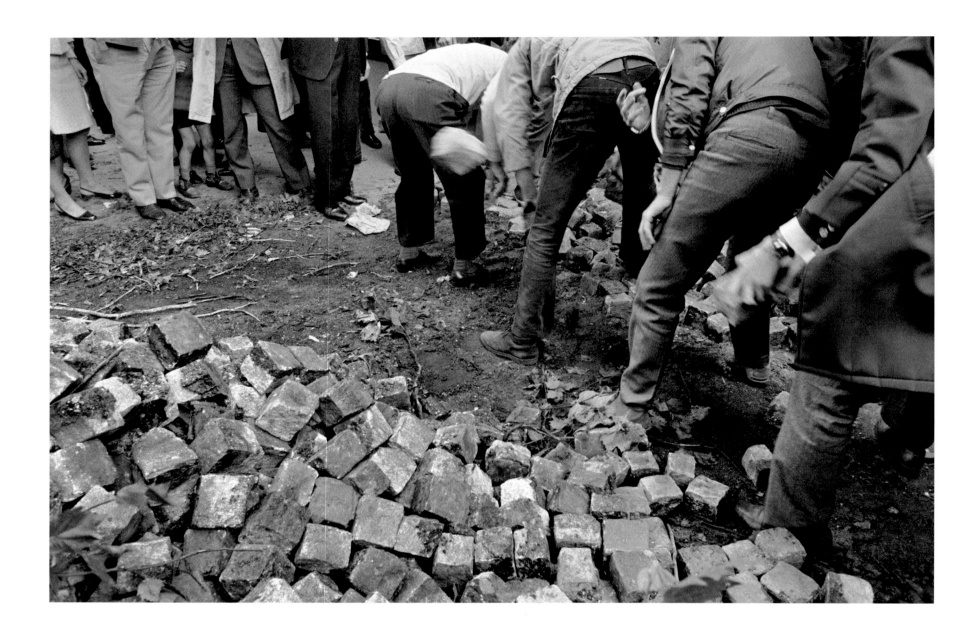

cat. 12. Building barricades near the Sorbonne, May 10, 1968.

cat. 13. Man and woman standing near debris on Paris boulevard near the Sorbonne, May 11, 1968. ➤

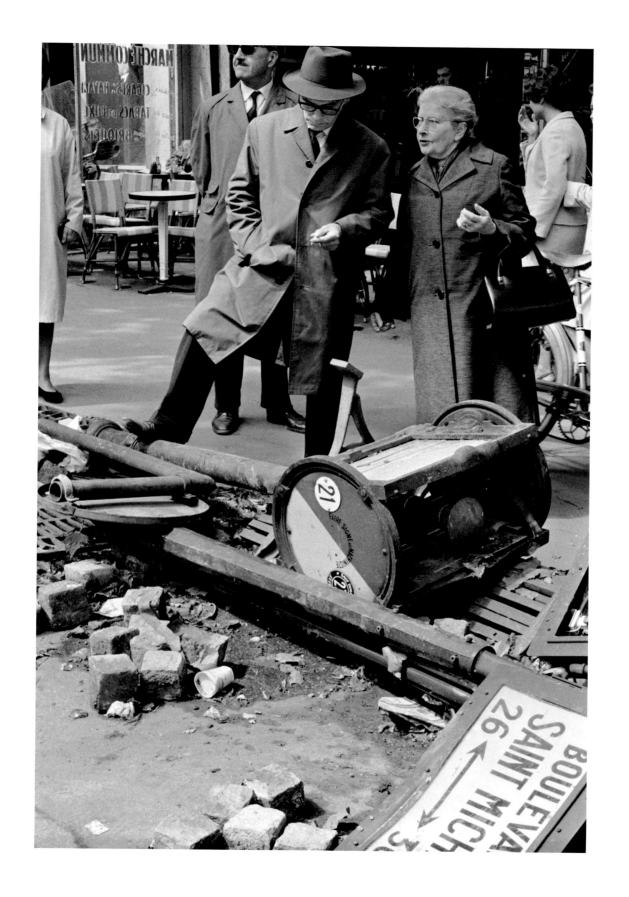

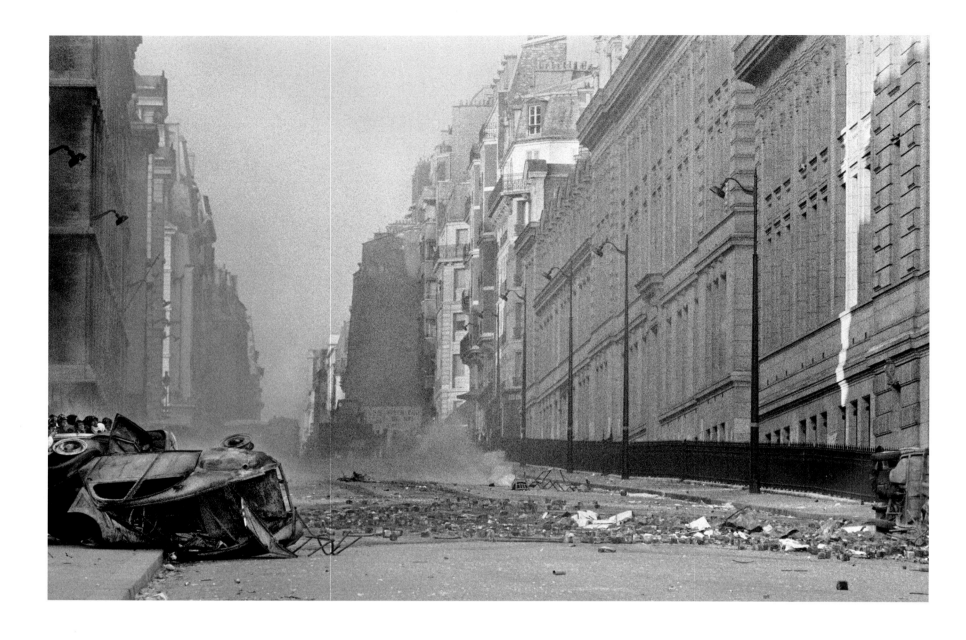

cat. 14. Barricade and overturned car, rue St. Jacques; the Sorbonne is to the right, May 11, 1968.

cat. 15. View down the boulevard toward the Panthéon, May 11, 1968. ➤

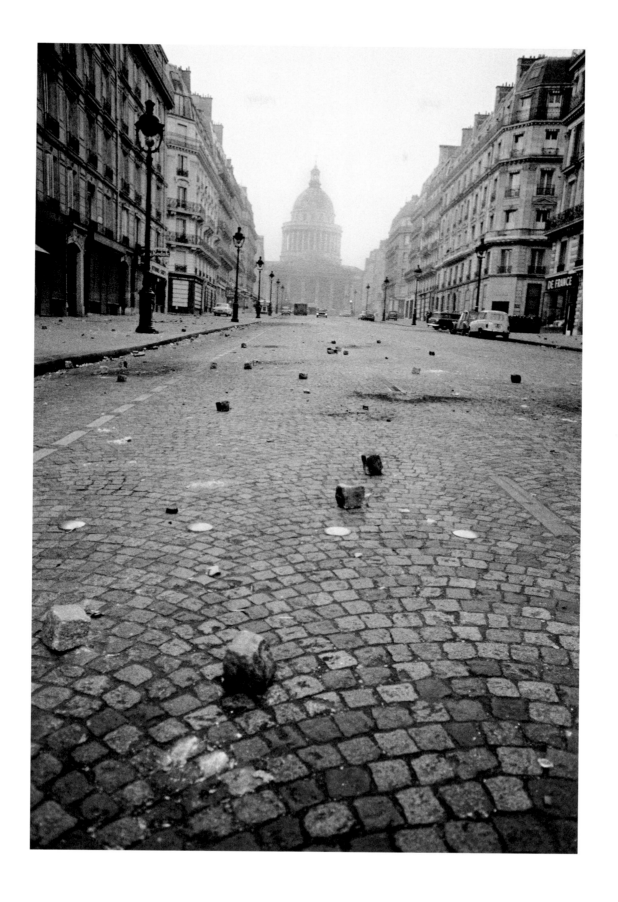

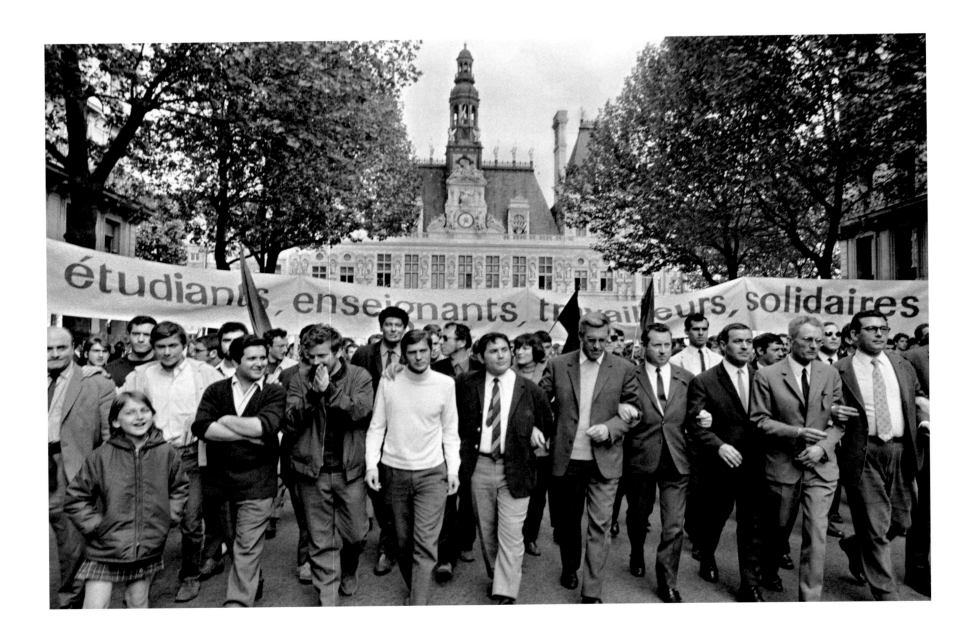

cat. 16. Student leaders Alain Geismar (arms crossed), Daniel Cohn-Bendit (hands in front of his face), and Jacques Sauvageot (in turtleneck) march together during student/ worker demonstration, March 13, 1968.

cat. 17. Student leader Jacques Sauvageot at demonstration, May 13, 1968. ➤

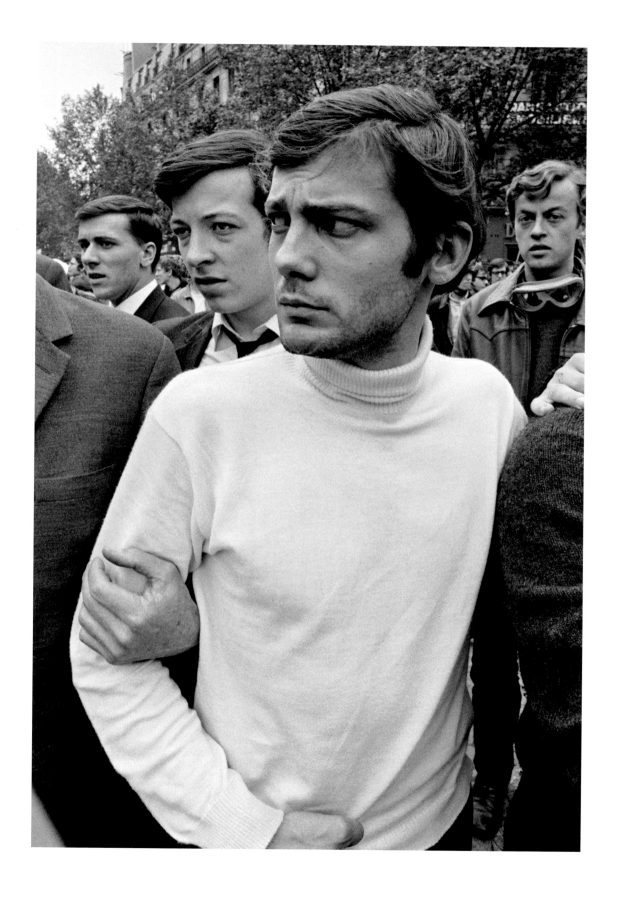

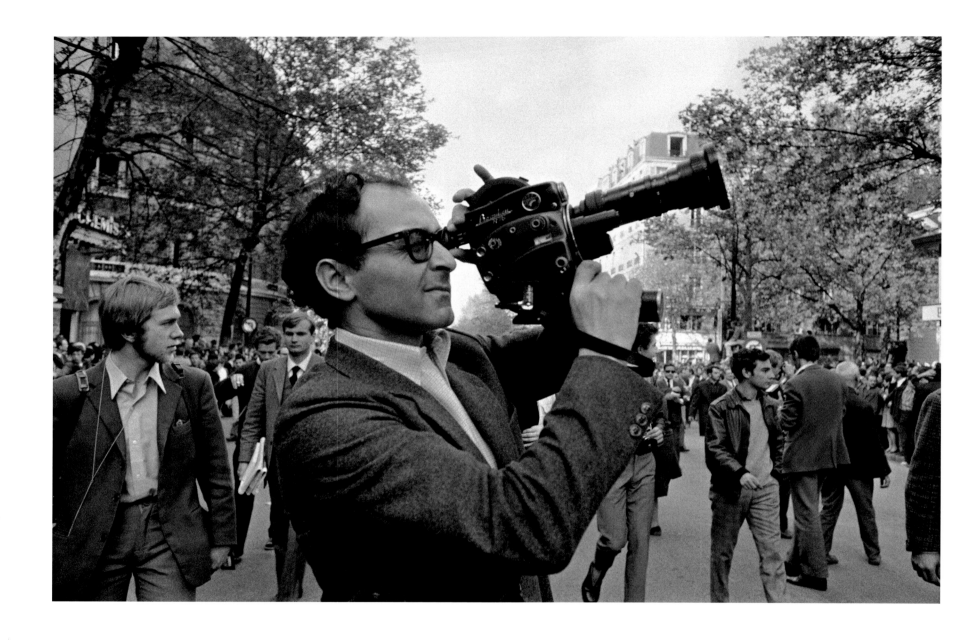

cat. 18. Jean-Luc Godard filming, May 13, 1968.

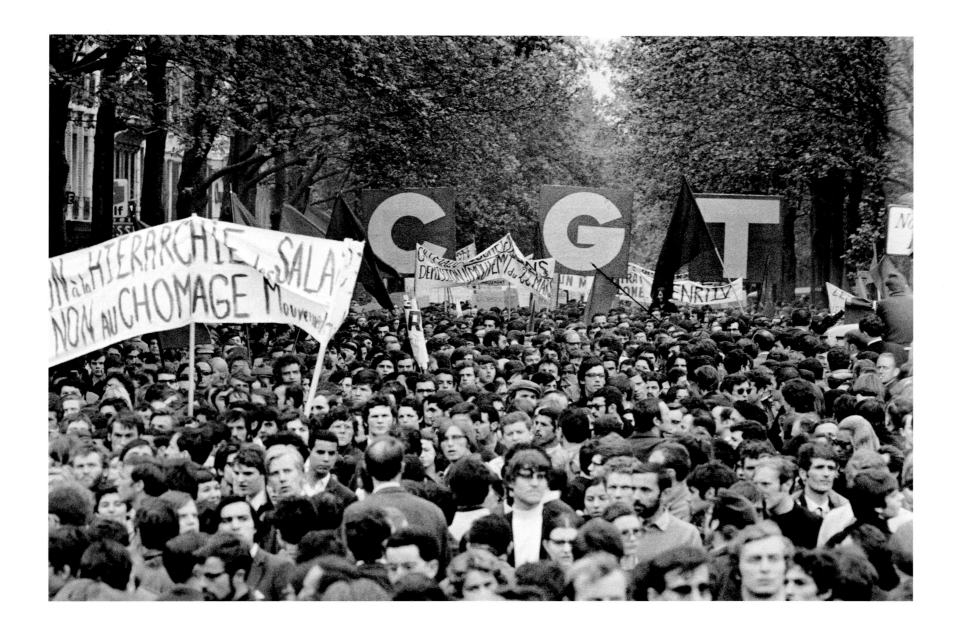

cat. 19. Demonstration with workers carrying CGT banner (Confédération
générale du travail, or General Confederation of Labor), May 13, 1968.

cat. 20. Demonstrator holding tear gas grenade, May 13, 1968.

cat. 21. Marchers carrying flags, May 13, 1968. ➤

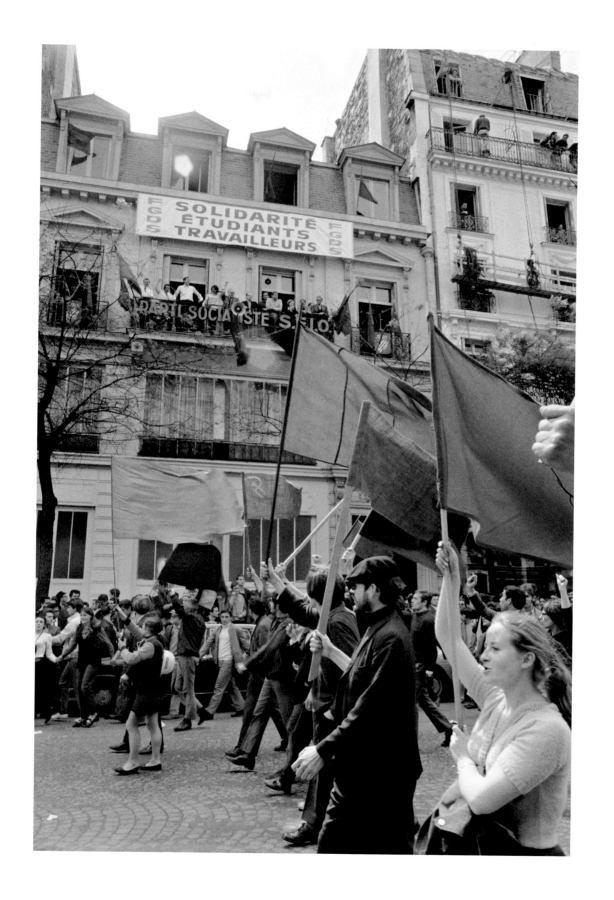

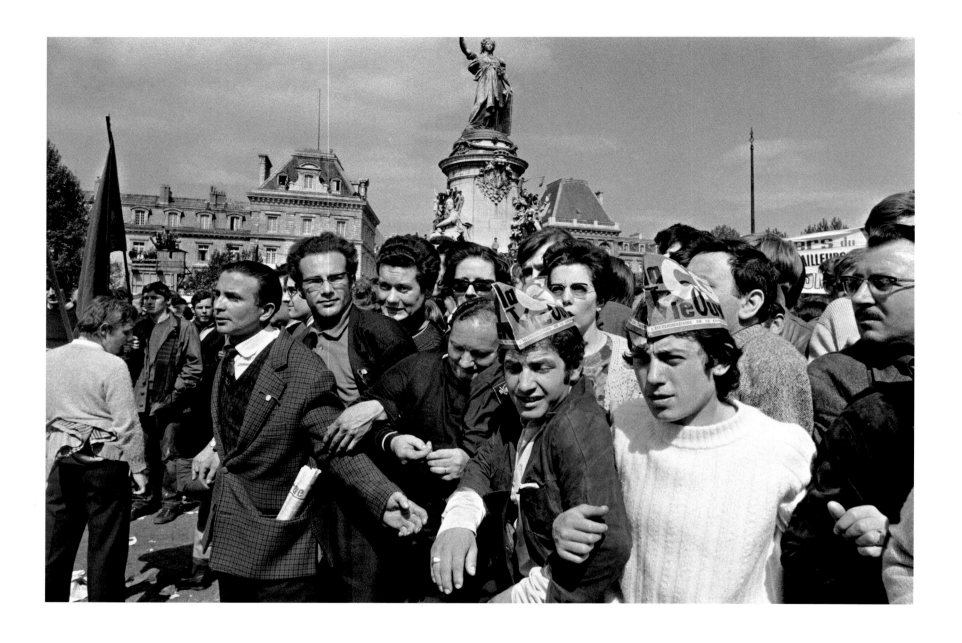

cat. 22. Protestors at the Place de la République, May 13, 1968.

cat. 23. Man with sign mounted on broom reading "For Sweeping
away the Police State," during demonstration, May 13, 1968. ➤

cat. 24. Sorbonne Courtyard, May 1968.

cat. 25. Two students at the Sorbonne sitting next to statue of Louis
Pasteur with graffiti reading "Liberate Expression," May 1968. ➤

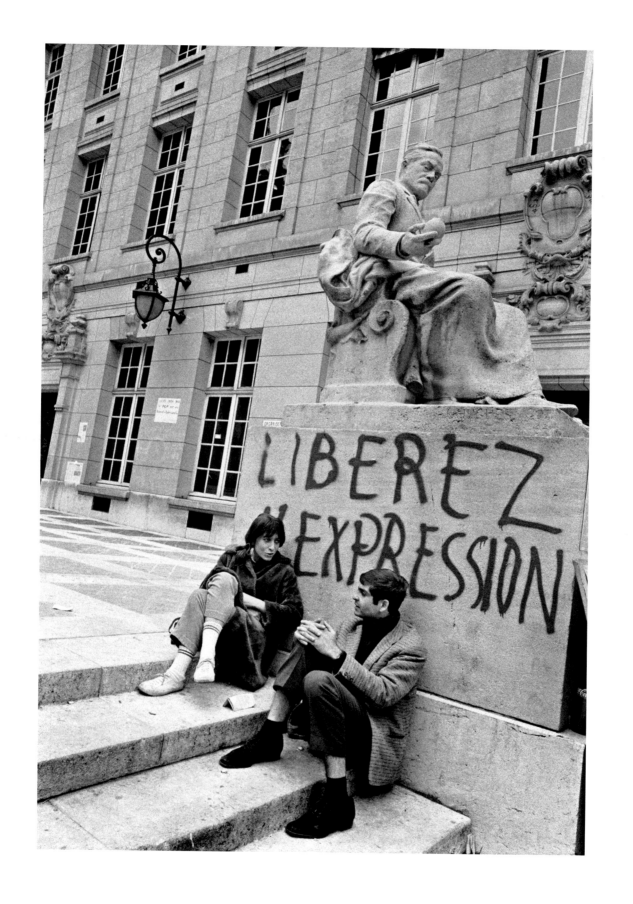

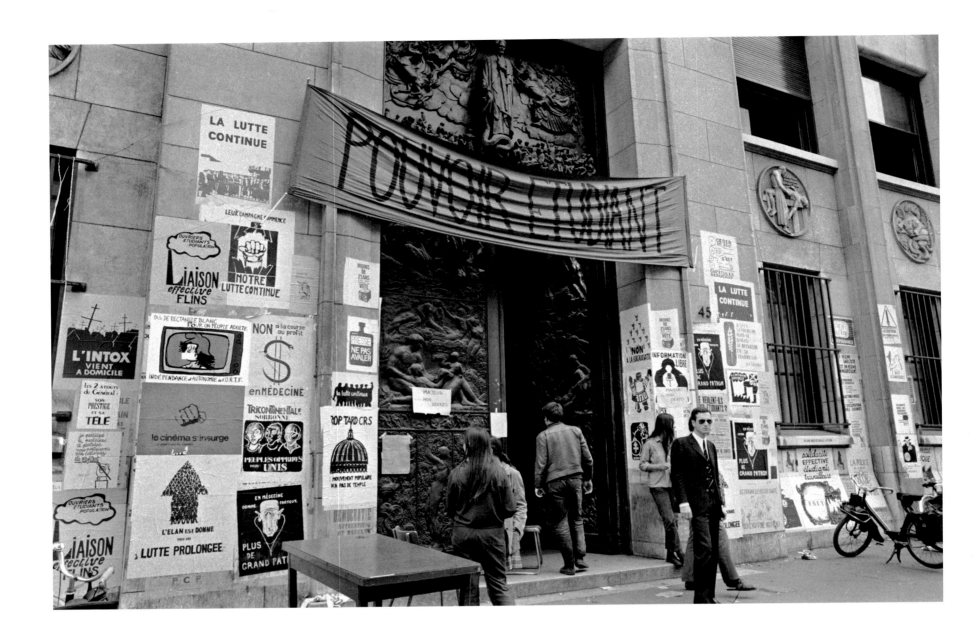

cat. 26. Posters at the Faculté de Médecine with banner above door reading "Student Power," May 1968.

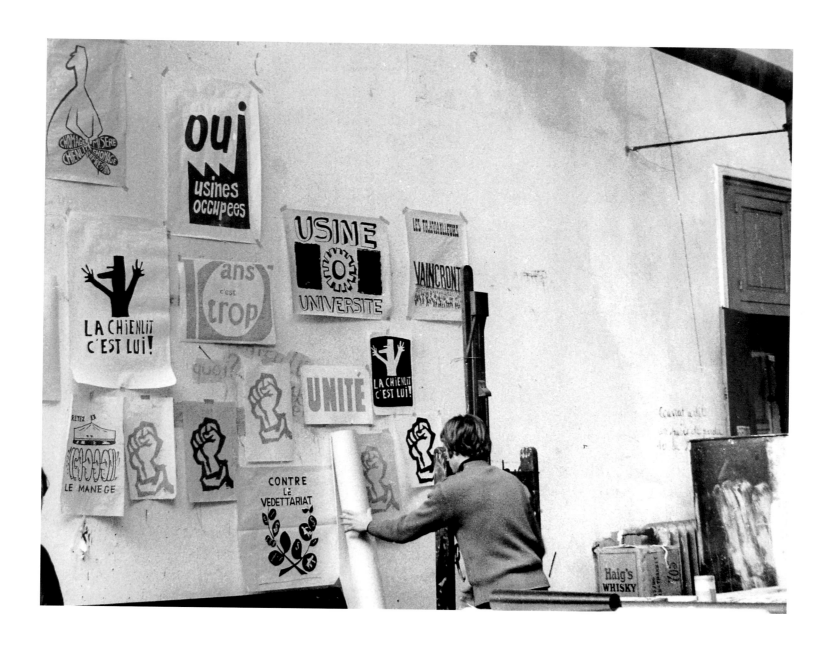

cat. 27. Posters in classroom at an atelier at the École des Beaux-Arts, May 1968.

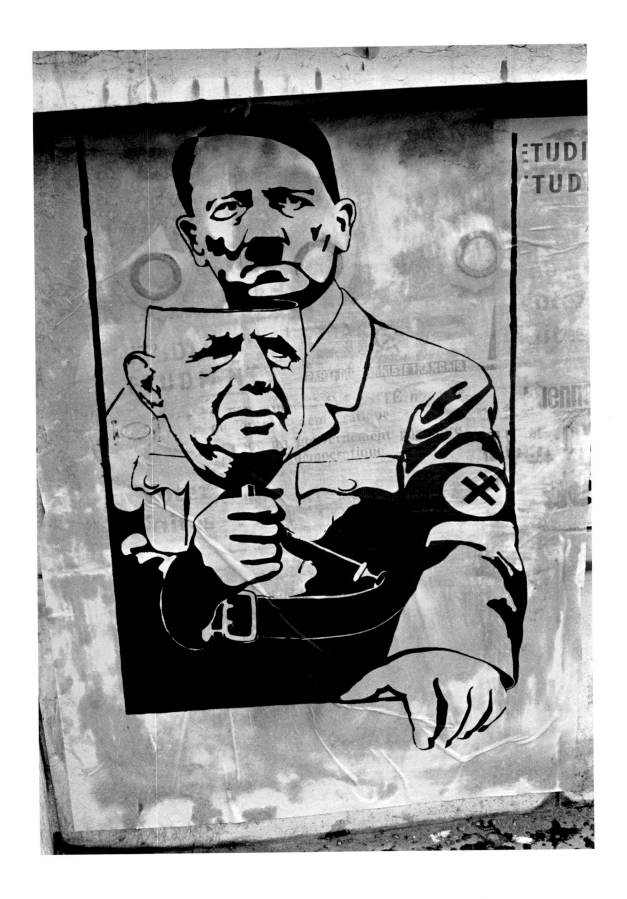

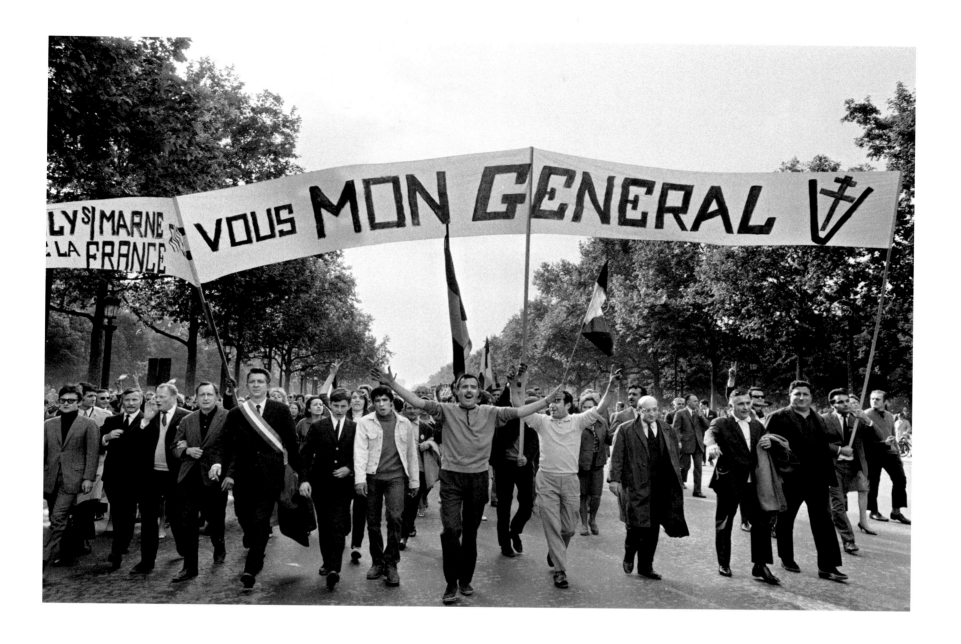

cat. 29. Pro-Gaullist demonstration, May 30, 1968.

◄ cat. 28. Poster showing Hitler with a de Gaulle mask; the Cross of Lorraine
replaces the swastika on his armband, May 1968.

cat. 30. Pro-Gaullist demonstration at the Arc de Triomphe, May 30, 1968.

cat. 31. Pro-Gaullist demonstrators waving the French flag, May 30, 1968. ➤

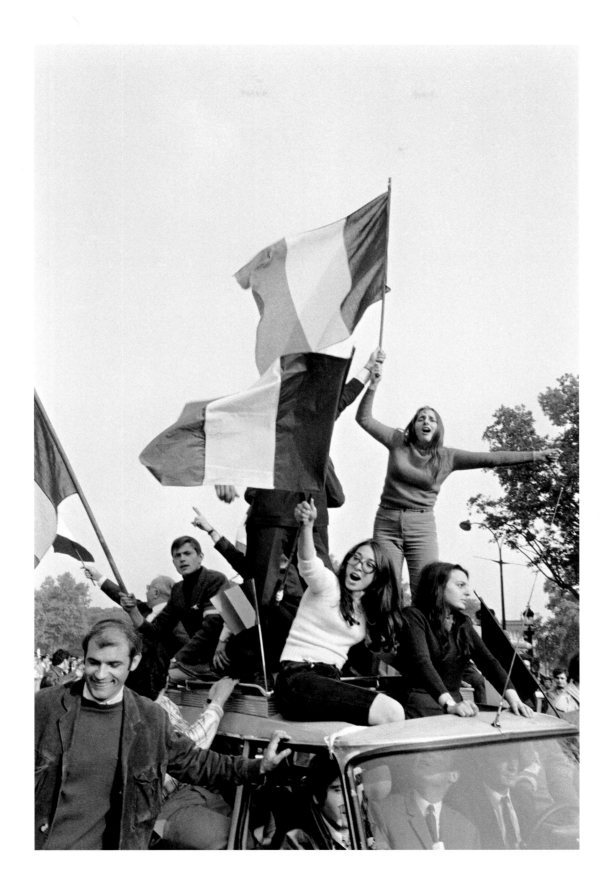

cat. 32. Pro-Gaullist demonstration, May 30, 1968.

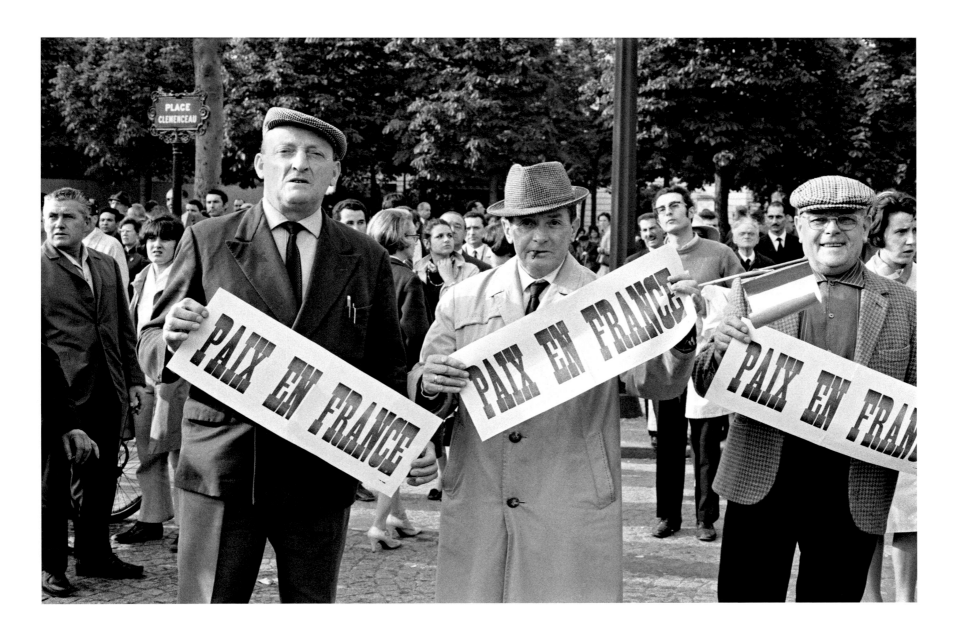

cat. 33. Pro-Gaullist demonstrators with "Peace in France" signs at the Place Clemenceau, May 30, 1968.

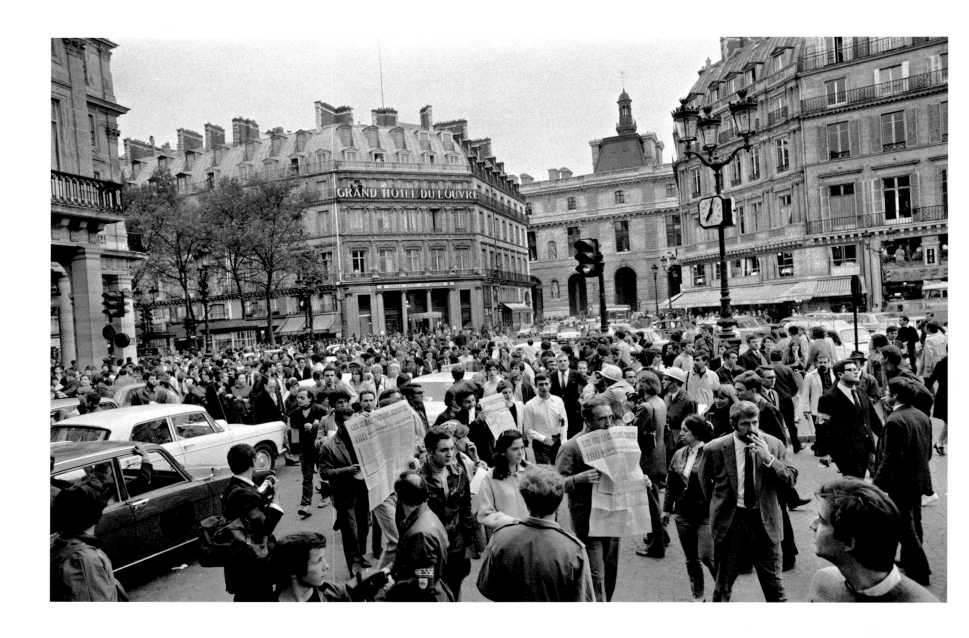

cat. 34. Demonstration of artists, writers, and students, Place du Palais Royal, July 16, 1968.

cat. 35. Arrested protestor at the demonstration of artists,
writers, and students, Place du Palais Royal, July 16, 1968. ➤

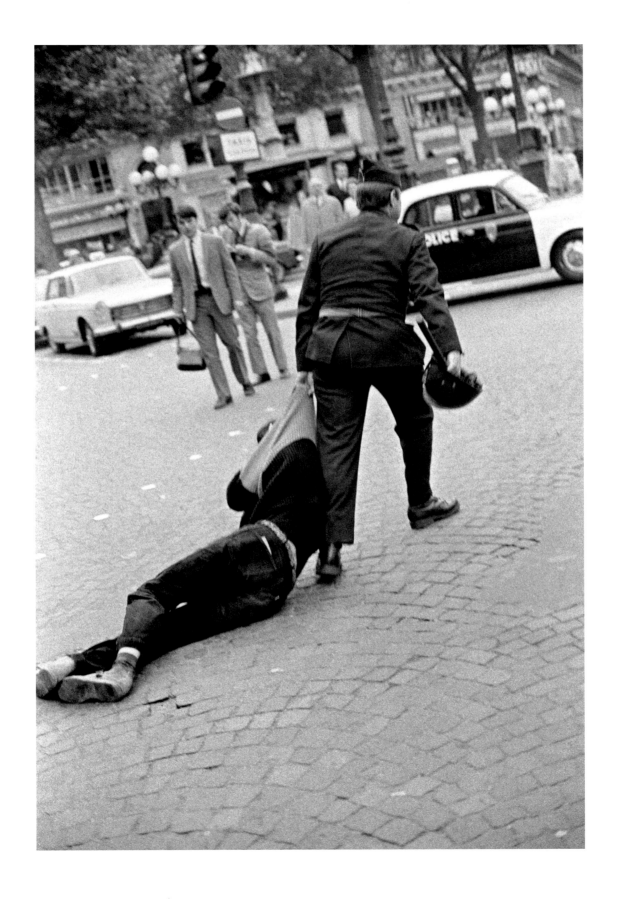

Protest in Paris 1968:
A Short Bibliography

For an introduction to French politics, see Anne Sa'adah, *Contemporary France: A Democratic Education* (Lanham: Rowman & Littlefield, 2003). On the educational system, see the work of Antoine Prost and François Dubet, and especially Prost's *Education, société et politiques: Une histoire de l'enseignement de 1945 à nos jours*, rev. ed. (Paris: Le Seuil, 1997), and *Histoire générale de l'enseignement et de l'éducation en France*, vol. 4, *L'école et la famille dans une société en mutation (1930–1980)* (Paris: Nouvelle Librairie de France, 1981).

The following works deal specifically with the "events" of May 1968 in France.

Documents

The best printed collection of primary source documents remains the large volume edited by Alain Schnapp and Pierre Vidal-Naquet, *Journal de la Commune étudiante: Textes et documents, novembre 1967–juin 1968* (Paris: Le Seuil, 1969). Selected posters (and more photographs) are reproduced in Bruno Barbey/Galerie Beaubourg, *Mai 68 ou l'imagination au pouvoir* (Paris: La Différence, 1998).

Narratives

Laurent Joffrin, *Mai 68: Histoire des événements* (Paris: Le Seuil, 1988), provides a relatively straightforward account of the May events as they played out in Paris. Hervé Hamon and Patrick Rotman, *Génération*, vol. 1, *Les années de rêve,* and vol. 2, *Les années de poudre* (Paris: Le Seuil, 1987, 1988), based in part on interviews, recounts the political experience of the 1968 generation from the early 1960s through the mid-1970s by following a finite number of student activists. The book is intended to read like a novel, and often does. No attempt is made to choose a representative cast of characters, but the book meets its own goals well and is a standard reference.

Memoirs

Daniel Cohn-Bendit returned to political life and has had frequent occasion to comment on the events in which he played so central a role. See *Le grand bazar* (Paris: Belfond, 1975) and *Nous l'avons tant aimée, la révolution* (Paris: Bernard Barrault, 1986), as well as a conversation with Bernard Kouchner facilitated by another veteran of 1968, Michel-Antoine Burnier, published as *Quand tu seras president . . .* (Paris: Laffont, 2004).

Biographies of, and memoirs by, major political figures (Charles de Gaulle, Georges Pompidou, Pierre Mendès France, François Mitterrand, and so on) typically include chapters on May 1968. Of particular interest are the memoirs of two men who were at the center of the storm during the events: Police Prefect Maurice Grimaud, *En mai, fais ce qu'il te plaît* (Paris: Stock, 1977), and Nanterre Dean Pierre Grappin, *L'Ile aux peupliers: De la Résistance à mai 68: Souvenirs du doyen de Nanterre* (Nancy: Presses Universitaires de Nancy, 1993).

Interpretations

Among the innumerable books and essays published on May 1968, the following are especially important, either for the analysis they offer (at different points in time) or for the debates they provoked, or both:

Cornelius Castoriadis, Claude Lefort, and Edgar Morin, *Mai 68: La brèche, suivi de Vingt ans après* (Brussels: Editions Complexe, 1988), includes essays written in 1968 and revisited twenty years later.

Alain Touraine, *The May Movement: Revolt and Reform*, tr. Leonard F. X. Mayhew (New York: Irvington, 1971, 1979), originally published as *Le mouvement de mai ou le communisme utopique* (Paris: Le Seuil, 1968).

Raymond Aron, *The Elusive Revolution: Anatomy of a Student Revolt* (1969), originally published as *La Révolution introuvable* (Paris: Fayard, 1968).

Stanley Hoffmann, *Decline or Renewal? France since the 1930s* (New York: Viking, 1974), Part II.

Luc Ferry and Alain Renaut, *La pensée 68: Essai sur l'antihumanisme contemporain* (Paris: Gallimard, 1985).

Henri Weber, *Que reste-t-il de mai 68? Essai sur les interprétations des "événements,"* 2nd ed. (Paris: Le Seuil, 1988, 1998)

Jean-Pierre Le Goff, *Mai 68, l'héritage impossible* (Paris: La Découverte, 1998, 2002).

May 1968 in Fiction

Robert Merle, *Behind the Glass*, tr. Derek Coltman (New York: Simon and Schuster, 1972), originally published as *Derrière la vitre* (Paris: Gallimard, 1970), set at Nanterre.

Films

Jean-Luc Godard's *La Chinoise*, often mentioned in connection with the May events, was released in June 1967.

Coup pour coup, Marin Karmitz (1972)

Mourir à trente ans (Half a Life), Roman Goupil (1982)

Milou en mai (May Fools), Louis Malle (1990)

The Dreamers, Bernardo Bertolucci (2003)

—A.S.

The Artist

SERGE HAMBOURG is an independent photographer who in the 1960s and 1970s worked directly for the magazine *Le Nouvel Observateur* (1966–69) and the newspaper *Le Figaro* (1973–77). He has also worked as a producer of television films (1970–72) and as a publicity photographer for advertising agencies such as J. Walter Thompson and Young and Rubicam (1961–66). His photographs have been produced in books, magazines, and journals, including *Paris Match, New York Magazine, Time, Vogue, Le Monde, Art in America, Fortune, Architectural Record,* and many others. They are in the collections of museums including the Museum of Fine Arts, Houston, the New-York Historical Society, the New Orleans Museum of Art, the Minneapolis Institute of Arts, and the Hood Museum of Art. His work has been exhibited at museums and galleries around the world. From 1977 through 1992 he lived in New York City. He now lives and works in Paris.

The Contributors

M. ANNE SA'ADAH is Joel Parker Professor of Law and Political Science at Dartmouth College, where she recently served as chair of the Department of Government. She received her A.B. in Social Studies and her Ph.D. in Political Science from Harvard University. Her research focuses on political development and democratic politics (including democratic failure) in Western Europe and the United States. In her writing, she has sought to elucidate when, why, and how human communities come to organize themselves in ways that maximize *both* productive conflict and inclusiveness. She is therefore particularly interested in what happens when societies face moments of deep and disorienting change, moments when democratic politics is a possibility, but sometimes only one possibility among others and in any case capable of taking a variety of forms (some more conflict-friendly and inclusionary than others): the revolutionary periods in England, America, and France,

Reconstruction in the United States, and postwar and post-unification Germany. When, why, and how do democrats win? When do reformists, rather than revolutionaries or reactionaries, manage to prevail? "For someone with my interests," she notes, "modern France, with its multiple fractures, its vibrant nationalism, and its contested liberal tradition, has always seemed a goldmine—quite apart from the more obvious pleasures that derive from doing research there." Her most recent book, *Contemporary France: A Democratic Education* (2003), uses modern French politics to analyze the recurrent challenges that attend the political project of combining conflict and community. Professor Sa'adah is also the author of *Germany's Second Chance: Trust, Justice, and Democratization* (1998) and *The Shaping of Liberal Politics in Revolutionary France: A Comparative Perspective* (1990). An article she published during the controversy over Joschka Fischer's radical past ("'Ein Staatsmann mit Geschichte': Joschka Fischer's German Past," *German Politics and Society*, Vol. 19, No. 3 [Fall 2001], pp. 56–79) deals in part with the legacies of the German student movement of the 1960s.

THOMAS CROW is Director of the Getty Research Institute at the Getty Center, Los Angeles, and Professor of the History of Art at the University of Southern California. He was previously Robert Lehman Professor of Art History at Yale University and Chair of the History of Art at the University of Sussex in the United Kingdom. His first book, *Painters and Public Life in Eighteenth-Century Paris*, appeared in 1985 and won a number of awards. He has since published on French painting of the Revolutionary period (*Emulation*, 1995, 2nd ed. 2006) and on the art of the later twentieth century (*The Rise of the Sixties*, 1996, 2nd ed. 2005; *Modern Art in the Common Culture*, 1996). His subsequent book, *The Intelligence of Art* (1999), reassessed the present state of art history via a close analysis of specific moments of interpretation. Professor

Crow has recently published a survey of the life and work of artist Gordon Matta-Clark (2003) and major essays for the Museum of Contemporary Art, Los Angeles, on Robert Smithson (2004) and Robert Rauschenberg (2006). His writings have been translated into French, German, Italian, Korean, and Spanish. A contributing editor of *Artforum*, he writes frequently on contemporary art and cultural issues and contributes reviews, catalogue essays, and forewords to national and international arts publications.